Alter This!

Alter This!

RADICAL IDEAS FOR TRANSFORMING BOOKS INTO ART

ALENA HENNESSY

LARK BOOKS
A Division of Sterling Publishing Co., Inc.
New York

Library of Congress Cataloging-in-Publication Data

Hennessy, Alena, 1977-
 Alter this! : radical ideas for transforming books into art / by Alena
Hennessy. -- 1st ed.
 p. cm.
 Includes bibliographical references and index.
 ISBN 1-57990-948-5 (hardcover)
 1. Altered books. I. Title.
 TT896.3.H455 2007
 745.593--dc22
 2006034669

10 9 8 7 6 5 4 3 2 1

First Edition

Published by Lark Books, A Division of Sterling Publishing Co., Inc.
387 Park Avenue South, New York, N.Y. 10016

Text ©2007, Alena Hennessy
Photography ©2007, Lark Books
Illustrations ©2007, Lark Books

Distributed in Canada by Sterling Publishing,
c/o Canadian Manda Group, 165 Dufferin Street, Toronto, Ontario, Canada M6K 3H6

Distributed in the United Kingdom by GMC Distribution Services,
Castle Place, 166 High Street, Lewes, East Sussex, England BN7 1XU

Distributed in Australia by Capricorn Link (Australia) Pty Ltd.,
P.O. Box 704, Windsor, NSW 2756 Australia

If you have questions or comments about this book, please contact:
Lark Books, 67 Broadway, Asheville, NC 28801, (828) 253-0467

Manufactured in China
All rights reserved

ISBN 13: 978-1-57990-948-2
ISBN 10: 1-57990-948-5

For information about custom editions, special sales, premium and corporate purchases,
please contact Sterling Special Sales Department at 800-805-5489 or sterlingsales@
sterlingpub.com.

Editor: Rain Newcomb
Creative Director: Celia Naranjo
Designer: Robin Gregory
Art Assistant: Bradley Norris
Editorial Assistance: Rose
 McLarney and Cassie Moore
Illustrator: Bernie Wolf
Photographer: Steve Mann,
 Black Box Photography
Photo Stylist: Skip Wade

Dedication

For my husband, Andrew, who is
nothing less than amazing. Words
cannot express my love and gratitude.
A. H.

The book used in the project on page 80 is Gene
A. Mittler's *Art in Focus*, 3rd Edition, ©1994,
Glencoe/McGraw Hill. Used with permission.

Contents

What is an Altered Book?

If you've ever doodled a mustache and horns on someone's photo in an old textbook, or drawn hearts around your crush in a yearbook, congratulations! You've already altered your first book.

When you transform a discarded novel, last year's phone book, or even a lovely book like this one into a piece of unique art, you've created an altered book. It could turn into a book all about you. With some photos, drawings, and storytelling, you could make your friends the stars of a wild adventure. Or

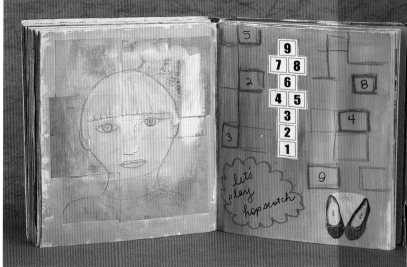

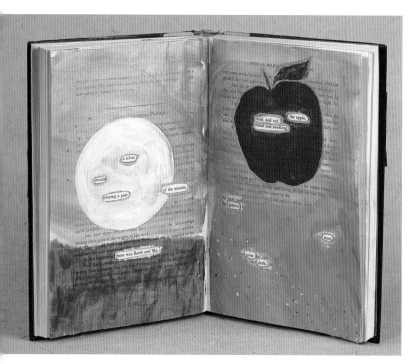

fill the book's pages with your artwork. An altered book might even become a secret box to hide special treasures in.

Altering a book can be as simple as drawing, painting, writing, or collaging something onto its pages. It can be as extreme as cutting holes, remaking the cover, weaving paper, or putting more books into it. Your book is a blank canvas, and if you can imagine it, you can do it.

But before you can liberate a plain old book from its humble beginnings, you need a book, a plan, and some tools. In this section, you'll find information on everything from finding the perfect book to choosing the right type of glue. The rest of this book contains fabulous projects, made by me and my friends, to inspire your creativity.

Finding the Right Book

Finding the perfect book to work with is the key to a good altered book project. You want to find a book that inspires your creativity and is sturdy enough to handle an extreme makeover.

Library book sales, garage sales, thrift stores, and secondhand bookstores are just some of the places where you could stumble across the perfect book, so keep your eyes open! These are also good places to go because you can get a lot of books without breaking your bank. (Then you'll have some money for your art supplies.) You might even be lucky enough to find an old stack of books collecting dust in your house. Just be sure they're destined for the thrift store before claiming them as your own.

WHERE NOT TO FIND BOOKS

So, it's probably not the best idea to alter any books that are checked out from a library. (Librarians frown on this.) Don't use your friends' books, your schoolbooks, your parents' treasured paperbacks, and so on. Always check with the original owner before altering a book.

Anatomy of a Book

Just like humans, books have their own anatomy. Take a moment to identify the different parts. (You can do it with this book.) I use the terms below when describing specific techniques in the projects, so you'll want to know what each one means.

The outside of a book has two **covers** and a **spine**. Inside you'll find the **text block**, which contains all the pages. The **end papers** are the thick paper inside the front and back covers. Two facing pages in a book are called a **spread**. Also notice the **gutter**, where two pages meet inside the book. Sometimes you can see the stitching between the pages in the gutter. The **binding** is where the pages are joined together.

Book Types

Books come with hard or soft covers, can be thick or slim, old or new, large or small. It's important to think about these factors when choosing your book. Look at all the projects in this book to get an idea about what kind of book you'll want to work with. For instance, you'll need to use a thick hardback book to make the Book Purse (see page 88), but a paperback would work well for drawing inside a book (see page 18). Some projects can be done in almost any type of book (including this one!).

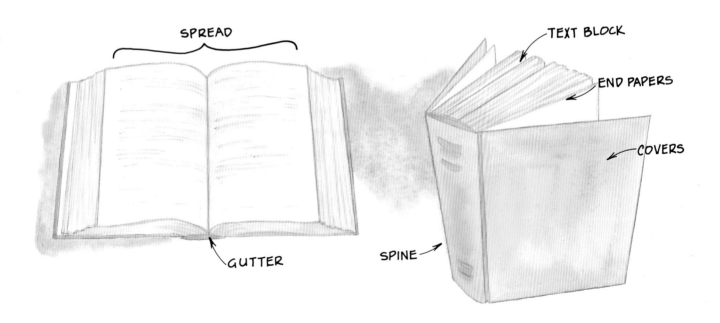

SPREAD

GUTTER

TEXT BLOCK

END PAPERS

COVERS

SPINE

HARDBACK BOOKS

Hardback books have hard covers. They're very sturdy, so they can handle lots of creative damage. If you're lucky, you can find ones with old illustrations inside. They're fantastic for a variety of projects. (See the Book Drawers on page 84 and Cover Up on page 38 for just a few examples.) There are two different types of hardback books: **sewn signature** and **perfect bound**. These terms refer to the way the pages are bound in the book. A sewn signature book has sewn pages. In a perfect bound book, the pages are glued to the spine. A sewn signature book can take a lot more wear and tear, which is essential for hard-core altering projects.

PAPERBACK BOOKS

Paperback books have paper covers. The best thing about them is that they're easy to find and super cheap. There are some funky paperbacks out there. I found some wonderful vintage ones with fantastic illustrations, like the one on page 24. Paperbacks are perfect for practicing your altering skills and testing out new ideas. Just keep in mind that if you add lots of heavy stuff, the book may fall apart.

BOARD BOOKS

For making altered books, many people choose board books, the kind with hard pages you had when you were tiny. All the pages are thick and can withstand lots of

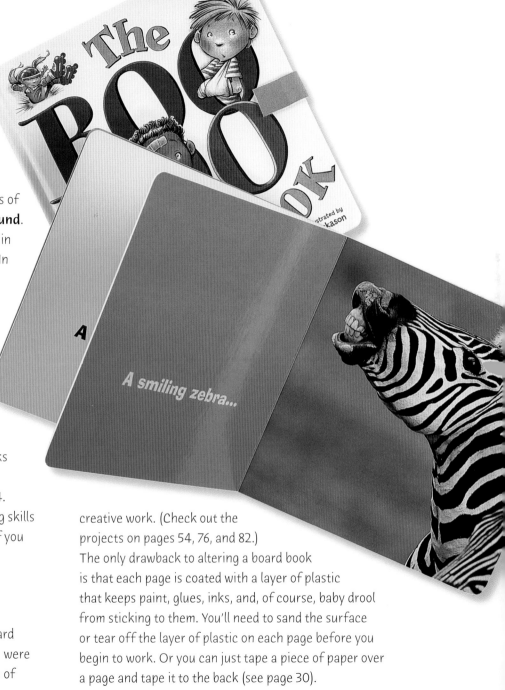

creative work. (Check out the projects on pages 54, 76, and 82.)
The only drawback to altering a board book is that each page is coated with a layer of plastic that keeps paint, glues, inks, and, of course, baby drool from sticking to them. You'll need to sand the surface or tear off the layer of plastic on each page before you begin to work. Or you can just tape a piece of paper over a page and tape it to the back (see page 30).

Other Books

Sometimes altering unusual books can be very rewarding. Try using phone books, journals, comic books, used address books, composition notebooks with old class notes in them, or anything you can find. There's a checkerboard made from a phone book on page 72.

Plan Ahead

Before you start any art project, it's always good to have a plan. That way, you'll know if you've picked the right book for your project. It's particularly important to plan ahead when you're going to be cutting shapes, pages, or niches into a book.

Flip through this book and pick out a project (or projects) that inspires you. Figure out what supplies you'll need. Think about colors you'll want to use and what steps you'll need to take. Make some sketches. Test out your ideas before you begin tearing up a book. Practice on books that have less value to you. When you have the perfect idea for altering the best book you found, you'll be ready!

Prepare Your Book

Before you begin, there are a few things you'll need to do to make your book ready for alteration. Here are some tips for getting your book ready for its transformation.

Page Strengthening

Pages in a book were originally intended for reading, not to be art canvases! Usually, painting a page with gesso or acrylic paint will thicken the page enough for you to decorate it without worrying about ripping the page. But if you want to cut holes in the page or glue 3-D objects to it, you'll need to strengthen it a bit more. Glue or sew several pages together.

Gluing

A glue stick is the least messy and quickest tool to use when sticking pages together. Put waxed paper between the glued and unglued pages to protect the pages you don't want to stick together.

Using white craft glue is a bit messier than using a glue stick. First, thin the glue by mixing it in a small bowl with an equal amount of water. Stick a sheet of waxed paper beneath the pages you're going to glue together. Use a piece of cardboard or a foam brush to spread the glue over the page, and then press the preceding page onto it. To get rid of the wrinkles, smooth the pages out with a library card. Glue three or four pages together at a time. Put another sheet of waxed paper in the book, sandwiching the glued pages together. Shut the book and stack a few more books on top. Let the glue dry before gluing any more pages together. Cover the leftover glue with plastic wrap until you're ready to use it again.

Sewing

Stitch a few pages together to make them sturdier. Thread your needle. Hold five or six pages together in one hand. Pierce the edges of the paper with the needle and sew through them. (If you're having trouble piercing the pages with the needle, use a hole-punch or a nail to make the holes.)

Closing Books

Adding a bunch of stuff, gluing pages together, or even just painting on the pages can break the binding of your book. If you don't mind, don't sweat it. If it's going to drive you crazy, it's easy to fix. All you have to do to avoid the dreaded binding-breaker is remove some pages. It's best to remove pages from the book before you start decorating it. That way, you won't accidentally cut into your artwork.

If you're painting, you'll need to remove a few pages for every page you paint. This is because the paint thickens the pages. Flip to an area of the book that you aren't using, hold it open, and put a piece of stiff cardboard between the section you're cutting and where your artwork will go. Use a craft knife to make a cut just outside the gutter. Be careful not to cut too deeply! It's better to go slowly and carefully.

You'll need to remove a bunch of pages in your book to make room for 3-D objects. Even then, you still may not be able to close your book afterward.

Background Preparations

Obviously, a book will be the background for everything you make. But you can decide how much of the original book you want to show. Below you'll find a few ways to make backgrounds before you paint, draw, write, or collage onto the book.

Gesso

Gesso is the best way to create blank canvases on your book's pages. It's what painters use to prepare their canvases. Gesso is like thick paint that makes a smooth surface for you to draw, write, paint, stamp, or collage on. It's easy to find at any art or craft store. Completely obliterate the background by painting several layers of gesso (let the paint dry between layers), or just paint one layer and let the original page show through. You can also color your gesso (see page 79.)

Paint

Paint the pages in your book. Control how much of the original text shows through by mixing your paint with water. The more water you use, the more **translucent** (see-through) the paint will be. Then the text will shine through.

PAPER

Adding paper to your book is a simple, mess-free way
to make a background. Use art papers, pages from
magazines or other books, scrap paper, or computer paper.
Be sure to line up the edges of your paper with the gutter
of the book. (If the paper overlaps the gutter, the book
won't close.) Fold the paper over the edges of a page and
tape it to the back side, or glue the paper to the page and
trim the edges off with a craft knife.

FABRIC

For something unique, use fabric to make a background.
The only drawback is that you won't be able to draw on
it with crayon or colored pencil. But you can glue
found objects on top of the fabric or decorate it
with fabric paint.

NO PREP

When you're too inspired to wait for gesso, paint, or glue
to dry, don't bother with a background. Use markers,
pencils, pens, crayons, colored pencils, chalks, stamps,
stickers, or ink to draw right on the pages.

Design

It always pays off to think about what you're doing before you start altering your book. This goes beyond just making sure that the window you're about to cut isn't going to destroy a great illustration on the back side of the page. (Although that's always a good thing to check, too!) Imagine what you'll want the page to look like when you're done. Think about the colors and shapes you'll use, and where you're going to put them. Look at the pictures below for ideas. Don't be afraid to try new things. Whether you're making a collage or deciding where to place a pop-up in your altered book, these ideas will help you make the most eye-pleasing pages possible.

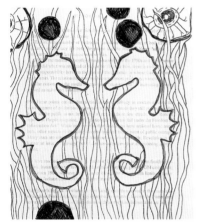

These sea horses are **symmetrically balanced**. Draw an imaginary line through the center. They're mirror images of each other.

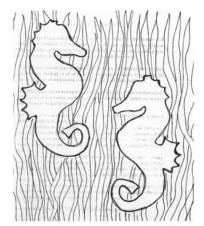

These sea horses are **asymmetrically balanced**. One is higher than the other, but the picture is still balanced.

Make a picture fantastic or realistic by changing the **proportions** of different pieces. I drew a tiny giraffe and gigantic flowers here. Check out the faces on page 24 for an example of realistic proportions.

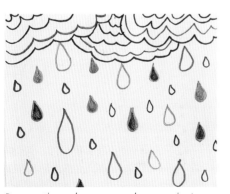

By repeating a shape over and over again, I created a **pattern** of raindrops in this picture.

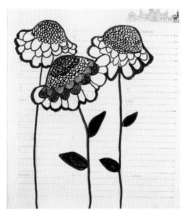

I used color to **emphasize** the center flower in this picture. That flower is the first one you look at in this picture.

Color

When choosing colors, remember that less is more. Using every color imaginable in your picture will make your eyes hurt. A good rule of thumb is never use more than six colors. Two or three colors are usually ideal. You can pick colors that look good together by looking at pictures, flower gardens, and nature for inspiration, or you can use a color wheel.

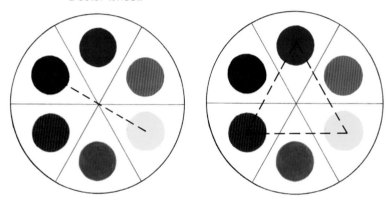

*Use two colors opposite each other or three colors that form a triangle to make a **complementary** color scheme. These colors pop when they're next to each other and will make a vivid picture.*

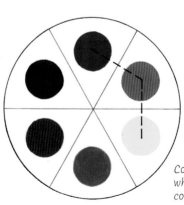

*A **monochromatic** color scheme uses multiple shades of the same color. (For instance, light, medium, and dark green.) This combination is great for creating an elegant and subtle picture.*

*Colors that are next to each other on the color wheel make an **analogous** color scheme. These colors look sophisticated and classic together.*

Tools & Materials

Here are just a few of the different tools and materials you can use to alter your books. Look around the house—you probably have most of these things already. While you're looking, keep your eyes open for other things you can experiment with.

Waxed Paper

Waxed paper is my favorite material because it protects other pages from getting messy. Place a sheet below the page you are painting or gluing. This will keep the paint and glue off the rest of the book. You could use plastic wrap instead of waxed paper, but it can be tricky to handle since it tends to stick to itself.

Cutting Tools

You'll be using cutting tools to create niches, cutouts, cool page shapes, and more in your book. The key to cutting is to be careful and patient. And please, please remember to take breaks! If you burn yourself out, you'll start to make mistakes, cut too far, or cut yourself. When you get tired, leave your project and come back to it later. This is an important skill that every artist has to learn.

Scissors

Use scissors to trim the edges off pages, or to cut out photos, images, or shapes for collaging. Specialty scissors are fun to use for collaging. They'll leave shapes, such as triangles or wavy lines, on the edges.

Craft Knife

A craft knife works just like a pencil, but instead of leaving a mark on the page, it makes a cut. You'll use it to create cutouts, niches, and weavings. Always cut away from your fingers when using a craft knife. Hold the book steady on the work surface with one hand. Hold the craft knife like a pencil in your other hand. Make a series of short, light strokes to make the cut. Don't make one long, hard stroke with the craft knife. The less pressure you use, the more accurate and safe the cut will be. Ask an adult to help you with this until you've got the hang of using this tool.

Box Cutter

Also called a utility knife, this tool is good to use to cut through covers or a lot of pages inside a book. Just like using the craft knife, hold the book steady and cut away from your hands. Don't use too much pressure. Shallow, soft strokes are more effective and safer. Again, ask an adult to help you until you're absolutely comfortable with the box cutter.

Paints

Paint is one of the easiest materials to use on your altered books. Experiment with different types of paint and find your favorite one to work with. Acrylic paints are my favorite. They dry quickly and can be cleaned up with water. Watercolors are fun for painting directly onto a page because the text and illustrations will show through. Tempera paint is an affordable option as well.

Always cover your work surface with newspaper and use waxed paper to protect the pages of your book you aren't painting. Give the paint time to dry before closing the book. Keep a piece of waxed paper over the dried paint for a week or two if you're going to close the book. This will give the paint a chance to get really dry.

Brushes

There are a lot of different kinds of brushes out there. A good rule of thumb is to use small brushes for painting small areas and larger brushes for painting larger areas. Beyond that, experiment to figure out what kinds of brushes you like best. Clean your brushes with hot, soapy water immediately after you use them and they'll be with you for a long time. Sponges, foam brushes, sticks, and toothpicks are also fun to try. (Foam brushes are fantastic for spreading glue, too!) And don't forget about your fingers. Using them to paint can be surprisingly satisfying.

Drawing Tools

You can draw, write, and color with anything you want. Pencils, pens, colored markers, colored pencils, chalk pastels, oil pastels, watercolor pencils, paint pens, crayons… The list goes on and on. Have fun playing with them all.

Sticky Stuff

Did I say waxed paper is my favorite material in making altered books? How could I have forgotten about sticky stuff? There are many ways to attach things to the page. Pick your favorite from this table.

Sticky Stuff Chart

Sticky Stuff	Use It On	Advantages	Disadvantages	Tips
Clear tape	Paper to paper	There's probably some in your house, and it's not messy at all.	It's not very strong, the stickiness wears out with age, and tape can look sloppy.	Double stick tape works better than regular tape.
Fabric glue	Glue anything to fabric	Dries clear	You can only use it when working with fabric.	It can stick your fingers together almost as well as super glue.
Glue stick	Paper to paper	Easy to use and very clean	It can only be used to stick paper to paper.	Apply to a flat surface
Rubber cement	Excellent for sticking photos and paper to paper	It will not wrinkle the paper or photograph.	May soften with age	If you use too much, you can rub it off easily.
Super glue	Heavier objects	It's a safe bet for securing heavy objects.	Once it's glued, it's glued. Don't get it on your fingers! They'll be stuck together forever! (Well, for a long time anyway.)	Use nail polish remover to get super glue off your fingers. Then wash your hands with soap and water.
White craft glue	Just about anything	Can be used on almost anything and dries fairly clear	It can wrinkle the paper if it pools up and then dries.	Mix it with water to make it the perfect consistency.

that are suit-
the flesh of
fish flesh is
fish in the
unk and let
into chunks

When they
nk. In this
interest in
eeding.
p is better
n until just
ed and let it
shrimp. Cut

uy in most
These are
rozen *adult*
mp, which
aquarium

kaged in
he freezer
ll piece of
th some

water. The shrimp will thaw and separate in a few minutes. Drain off the top of the water, you can use a medicine dropper to pick up a number of shrimp at a time and place them in the aquarium.

Some aquarium-supply stores also sell containers of living brine shrimp. These can be fed by netting them and transferring the net into the tank. The fishes seem to love the moving brine shrimp. They will clean them out in no time. The only problem is that living brine shrimp are more expensive than the frozen blocks. But you might like to give living brine shrimp to your fishes as a treat once in a while.

Some stores that specialize in marine tropicals carry other kinds of frozen foods. These include clams, squid, and even plants such as kelp. They come packaged in the same kinds of plastic bags as brine shrimp. Feed them to your fishes in the same way as you would any frozen food.

There are also many kinds of dry, prepared foods available in aquarium stores. The best of these are the ones that come in flakes. You can feed these to your fish by crumbling a pinch of the flakes between your fingers and dropping it into the tank. The pieces will float on the surface of the water. After a few minutes, you can easily remove the excess flakes with a net.

Don't use the packaged dry foods that are made up mostly of insect parts. They usually will not be eaten

Color your drawing. You don't have to color everything. I just colored in a petal or two. Stick with five (or fewer) colors. Keep it simple.

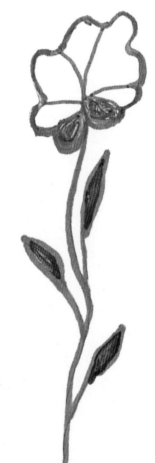

Markers, pencils, paint pens, colored pencils, crayons… Use anything you want.

Circle Poems

Books are filled with words just waiting for you to make them your own. Poetry has never been so easy!

Creating Poetry

1. You can do this project in any kind of book. I used an old children's book because I liked the way the larger words looked.

2. Scan the text. Choose your words and circle them with a pencil.

3. Carefully paint gesso around the words you've circled. (Use your smallest paintbrush.) Then paint the gesso over everything else. Let it dry.

4. Draw arrows and lines to connect the words of the poem. Add some words if you need to.

5. Decorate the page. I made a landscape (see page 26) that reflects the theme of the poem.

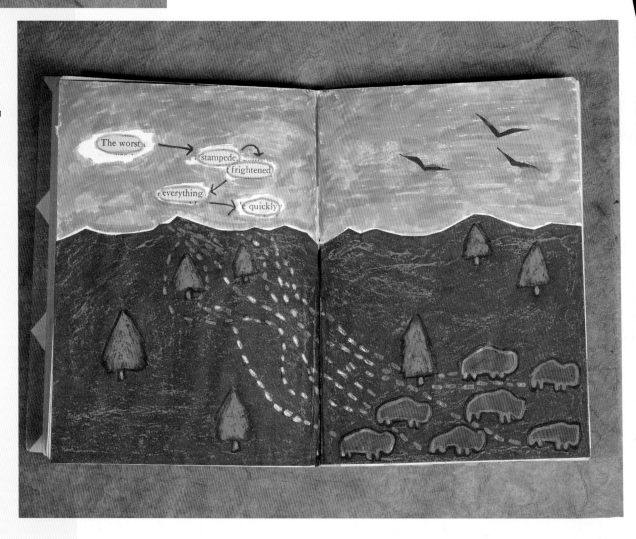

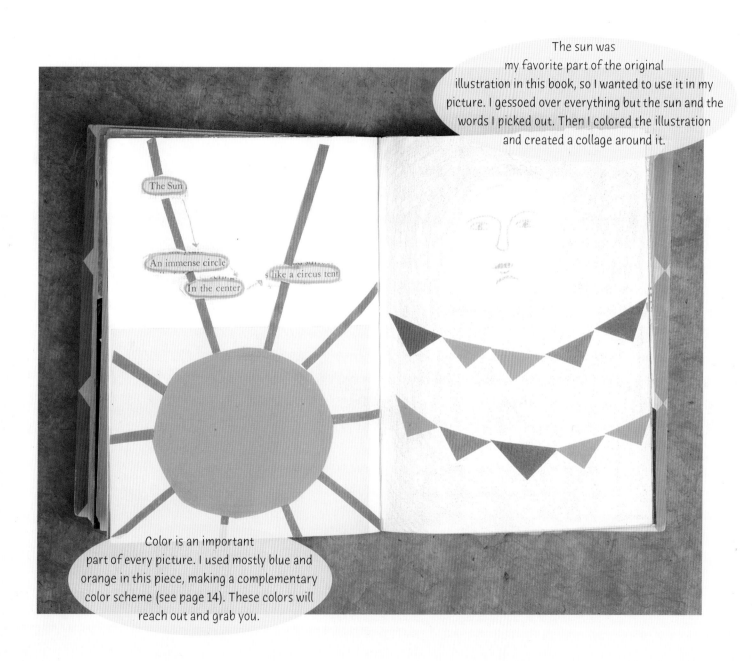

stamping

Not feeling like Picasso today? Then put down the paintbrush and use stamps to create your masterpiece.

Tips & Tricks

1. Press your stamp evenly into the ink pad.
2. Press the stamp on the page. Press it down steadily and firmly. Don't wiggle it or rock it back and forth.
3. Carefully lift the stamp straight up off the page.
4. Stamp off the excess ink on scrap paper before changing colors. Clean your stamps well when you're through.
5. To brighten things up, color in the outline of the stamp after the ink dries.

Styro-Stamps

1. Make an original stamp with styrofoam. Ask for some of the unused platters that hold veggies and meat at the grocery store.
2. Draw your design on the styrofoam. Use scissors or a craft knife to cut out the outline. Add details to the inside by jabbing a ballpoint pen or pencil into the foam.
3. To make a handle, glue a plastic bottle lid to the back of the stamp.

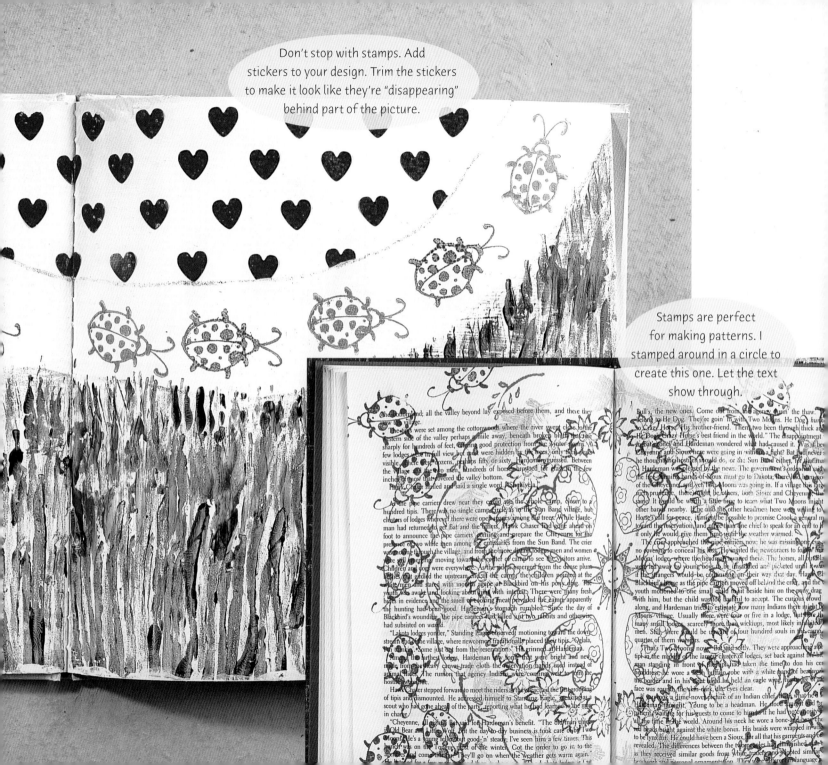

Don't stop with stamps. Add stickers to your design. Trim the stickers to make it look like they're "disappearing" behind part of the picture.

Stamps are perfect for making patterns. I stamped around in a circle to create this one. Let the text show through.

Making Faces

Give your friend a little face time by putting them in your book. Drawing faces may seem a little intimidating at first, but all you need is a little practice and this secret technique.

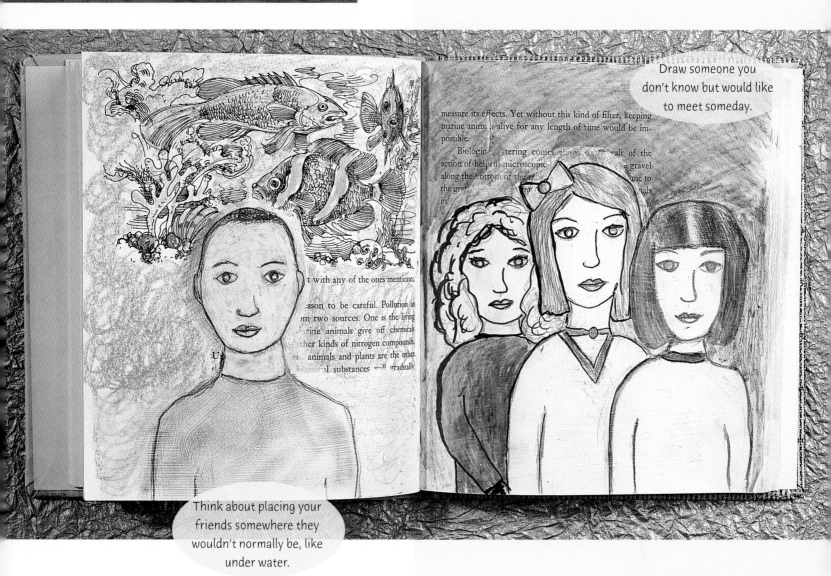

Draw someone you don't know but would like to meet someday.

Think about placing your friends somewhere they wouldn't normally be, like under water.

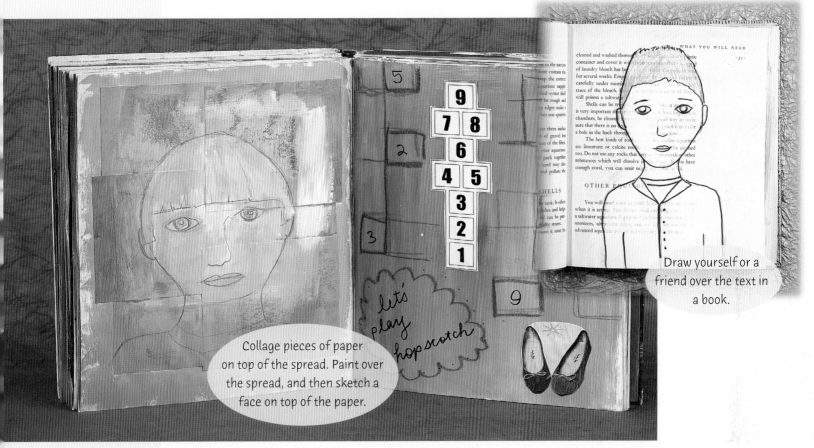

Collage pieces of paper on top of the spread. Paint over the spread, and then sketch a face on top of the paper.

let's play hopscotch

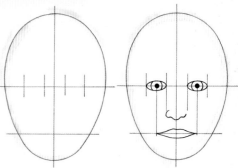

Draw yourself or a friend over the text in a book.

Drawing a Face

1. Draw an oval with a pencil. This is the outline of the head. Lightly sketch a horizontal line through the center of the oval. This is the eye line. Sketch a vertical line through the center of the oval.

2. Divide the eye line into five equal sections. Draw an almond shape for each eye. Inside the almond, draw a circle for the iris. The irises are perfectly round, even though you can't see the top or bottom. In the center of the iris, add a smaller circle for the pupil.

3. Lightly sketch a horizontal line between the eye line and the bottom of the oval. This line will show you where the nose and mouth will go.

4. Draw a curved line to indicate the bottom of the nose above the horizontal line you just drew. The sides of the nose will go between the eyes.

5. Draw the top lip above the line you drew in step 3 and the bottom lip below the line. Sketch a line from the middle of each eye to the mouth. These lines show you how wide the mouth should be.

6. Gently erase the extra lines you drew. Then trace over the portrait with a pen or marker.

Landscape

Creating a landscape is easy, and it makes a great background for an altered book project.

Sketching a Landscape

1. Find a landscape view that inspires you. Look outside or flip through photographs or magazines until you find a scene you like.

2. Choose a book. You can do this in any type of book, but you may want to practice in an old paperback. Lightly sketch two horizontal lines across the page, dividing the spread into three sections.

3. Start out by sketching the foreground. It should take up the lower third of your spread.

4. Create the middle ground. This should be in the middle third of your spread.

5. Add the background in the upper third of your spread.

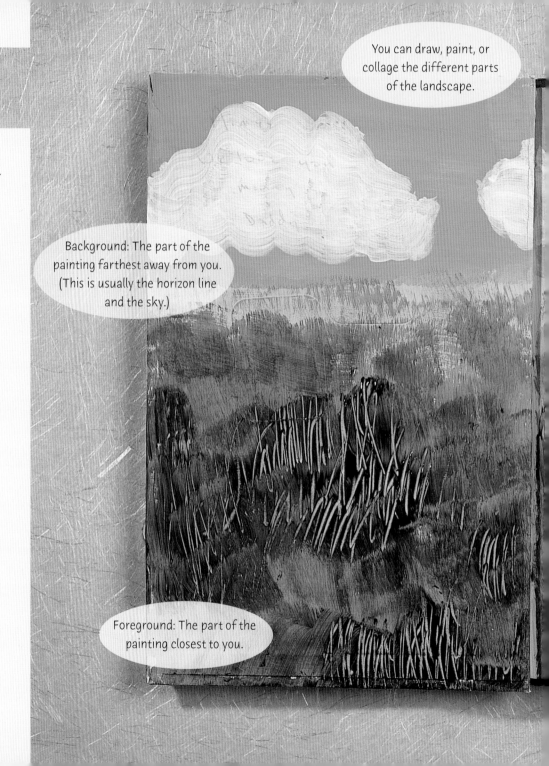

You can draw, paint, or collage the different parts of the landscape.

Background: The part of the painting farthest away from you. (This is usually the horizon line and the sky.)

Foreground: The part of the painting closest to you.

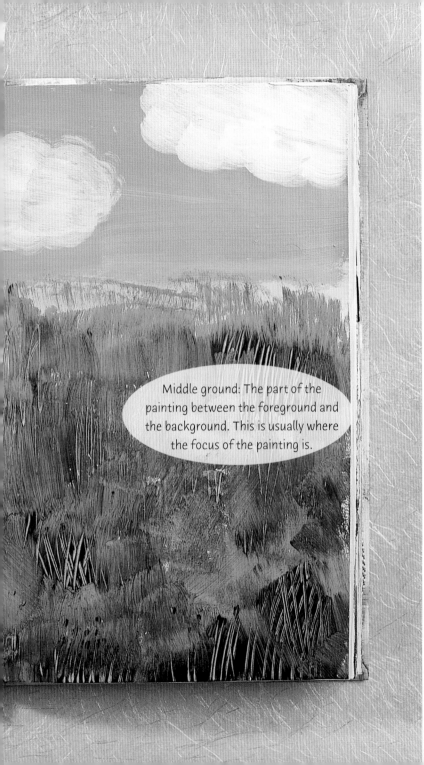

Middle ground: The part of the painting between the foreground and the background. This is usually where the focus of the painting is.

Scrape It

1. Paint your masterpiece. Let the paint dry a bit, but not too much. The paint should still be damp.

2. Find a scraping tool. This can be just about anything: the edge of a library card, your fingernail, or an old fork. I unbent a paper clip and used the end.

3. Drag the scraping tool through the wet paint. Scrape away paint. Make patterns if you like.

4. This simple technique is rather addicting—don't get too carried away! (But if you do, you can always paint over the area and try it again.)

Collage

A collage will give new life to old magazines— and get them out of your room!

When it comes to color, less is more. I only used blue, taupe, and white in this collage. The birds seem to pop off the page with these simple, contrasting colors.

Search & Arrange

1. Thumb through magazines, junk mail, and old books for images you like. I couldn't find the exact animals I wanted, so I drew them on a separate piece of paper and cut them out.

2. Paint the background of your spread. Let the paint dry.

3. Cut out your images and arrange them on the spread. When you like the new picture, put a small amount of glue on the back of each image. Then press them into place.

4. After the glue has dried, outline the images to make them stand out from the background. I used watercolor pencils to outline all the birds and draw the branches.

5. If you used glossy paper to make your collage, try paint pens for outlining.

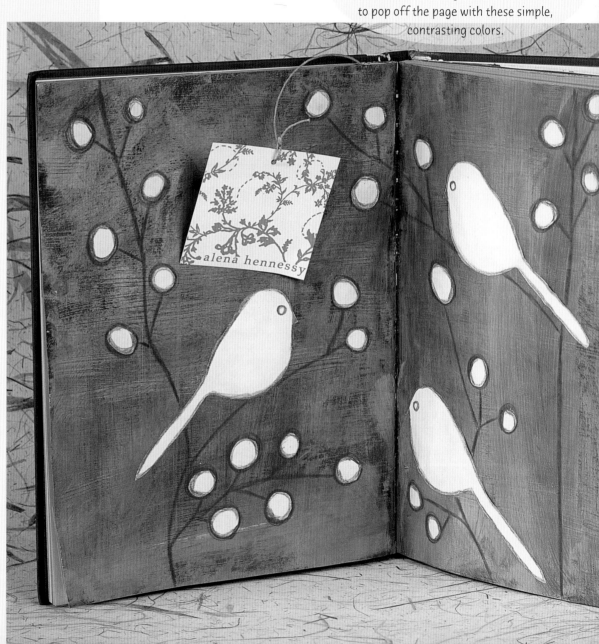

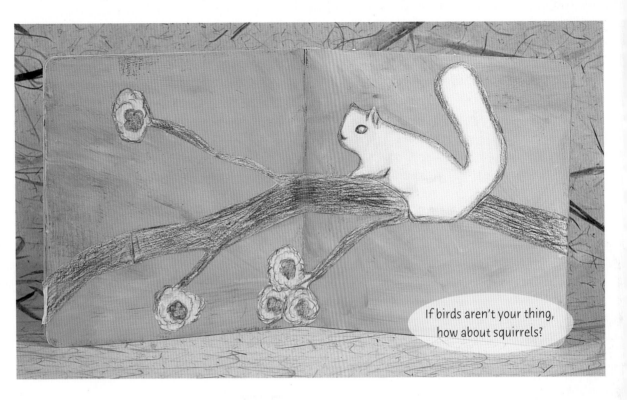

If birds aren't your thing, how about squirrels?

Put a lot of acrylic paint on the brush and make sweeping strokes across the entire spread. Let the paint dry and add more layers.

alena hennessy

Tag It

1. Make a bookmark and you'll never lose your place again. Cut out a small square of cardstock or construction paper.

2. Decorate the tag. Use markers, crayons, stickers, stamps—whatever you like. I have a stamp with my name on it.

3. Make a hole in your tag with a hole-punch and tie it to the end of a piece of twine.

4. Tape the other end of the twine to the inside back cover of your book.

spiral jump

Use a simple spiral cutout to give a great picture the attention it deserves.

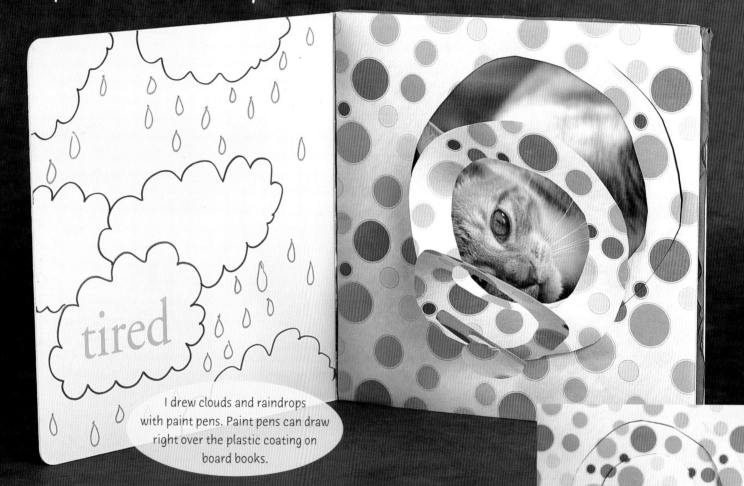

tired

I drew clouds and raindrops with paint pens. Paint pens can draw right over the plastic coating on board books.

The Spiral

1. Use a book that has lots of pictures in it, like a children's board book. Find a piece of paper that's larger than the page and looks good with the picture you've chosen. I chose a piece of polka-dotted scrapbooking paper.

2. Line up one edge of the paper with the gutter. Use a pencil to mark where you want the center of the spiral. You can choose a spot right above the center of the picture or off to one side.

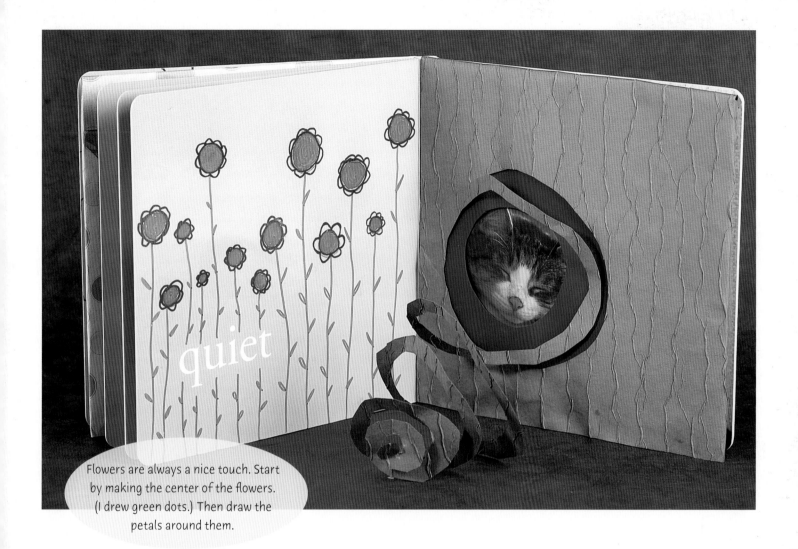

Flowers are always a nice touch. Start by making the center of the flowers. (I drew green dots.) Then draw the petals around them.

3. Remove the piece of paper from the book. Use a pair of scissors to pierce the pencil mark. With one hand, hold the scissors open and use the other hand to move the paper in a circle as you cut. You'll start out cutting the center of the spiral and move outward from there. (You may want to practice on some scrap paper first.)

4. Line up the edge of the spiral paper with the gutter again. Tape it in place with small loops of tape. Fold over the edges and tape them to the back of the page. Be sure the inside edge of the paper doesn't overlap the gutter. Otherwise, you'll have trouble closing the book. Trim the paper if you need to.

Bordered Spirals

If your spiral is too large (as in the picture above), make a border for the picture. Cut a smaller hole in another piece of paper. Tape it in place, and then tape the paper with the spiral cut out on top.

Do-It-Yourself Sticker

Make your own stickers—punk-rock style. Ted Harper, a graffiti artist, sculptor, and skateboarder, made this project.

Stick It

1. Find or create some drawings that you like. Make a photocopy of your favorite. (You can use a black-and-white photocopy or a color one to make a sticker.)

2. Cover the photocopy with strips of clear packing tape. Overlap the edges of the strips a little bit so the entire image is covered.

3. Trim away the excess paper and tape from around the image.

4. Soak the taped picture in warm water for about a minute. Then scrub off the paper with the rough side of a sponge until all that's left is the transparent image.

5. Let the tape dry. Then glue it to a page in your book. Color in parts of the image with permanent markers or paint pens.

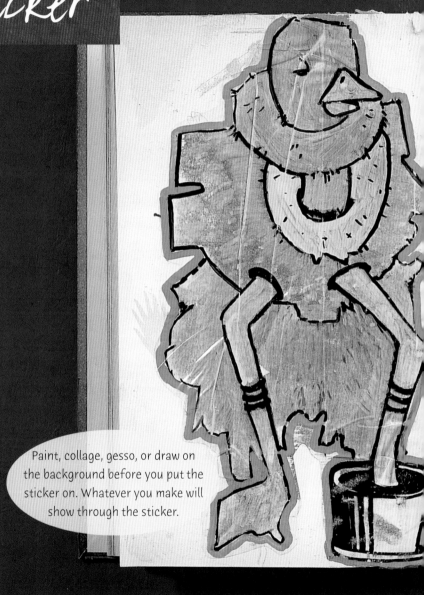

Paint, collage, gesso, or draw on the background before you put the sticker on. Whatever you make will show through the sticker.

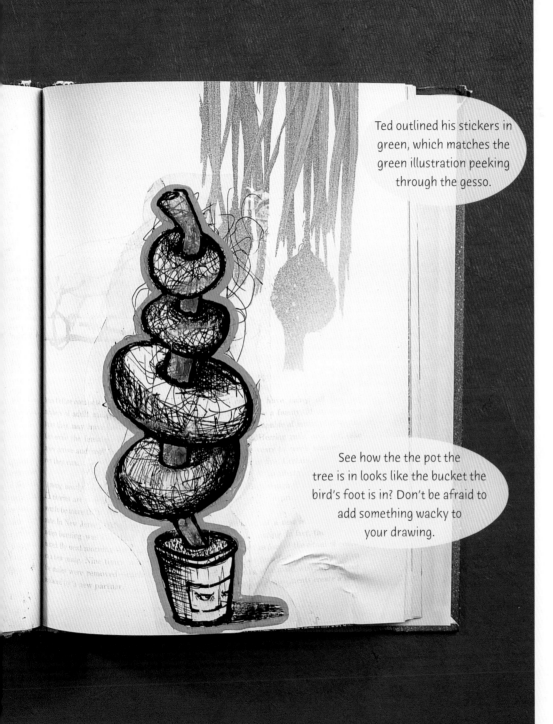

Ted outlined his stickers in green, which matches the green illustration peeking through the gesso.

See how the the pot the tree is in looks like the bucket the bird's foot is in? Don't be afraid to add something wacky to your drawing.

Cross-Hatching

1. This simple technique will add texture and shadows to your drawing. It works best with pen and ink, but you can do it with colored pencil, marker, or crayon.

2. Draw a series of parallel lines close together where you want a shadow.

3. Draw more parallel lines at a different angle on top of the ones you just made.

4. Keep drawing lines at different angles until you're happy with the shading. Remember: Too much shading can be just as bad as too little.

List Mania

Circle the Items

1. Using a nonfiction book about a subject you enjoy, scan the text. Look for words that fit your list.

2. Outline the words you've chosen. Make squares, rectangles, circles, or any other shape you can think of around them.

3. Gesso the pages. Be careful not to get any gesso on the words. Let the gesso dry, and then decorate the page.

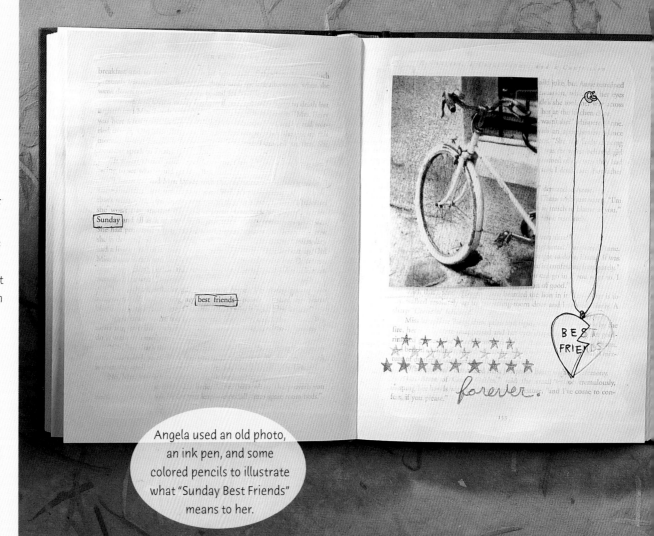

Angela used an old photo, an ink pen, and some colored pencils to illustrate what "Sunday Best Friends" means to her.

Combine drawings, photographs, and magazine cutouts.

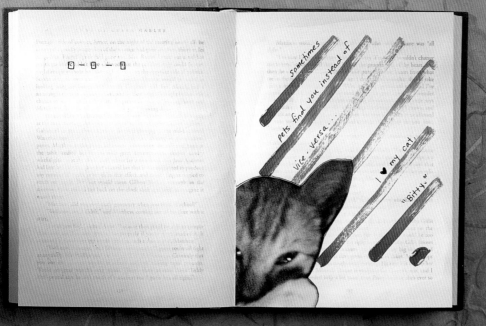

sometimes pets find you instead of vice versa...

I ♥ my cat, "Bitty"

Angela outlined the letters that spell the word cat. This is a great technique if you can't find the exact word you want.

Accordion Books

Hide a book inside another book. Then make it spring off the page (no 3-D glasses required.)

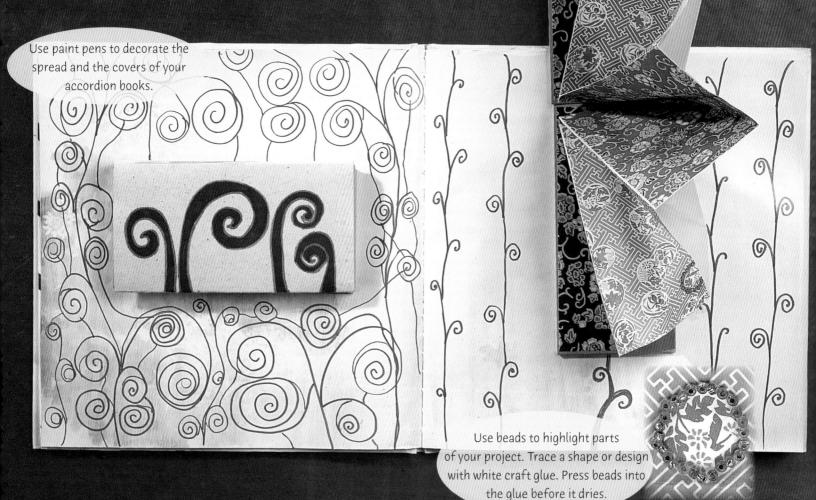

Use paint pens to decorate the spread and the covers of your accordion books.

Use beads to highlight parts of your project. Trace a shape or design with white craft glue. Press beads into the glue before it dries.

Making the Accordion Book

1. Lengthwise on a sheet of paper, use a ruler to mark a strip that's 5 inches wide. I used a sheet of computer paper for one book and origami paper for the other. Cut out the strip.

2. Decorate the front and back of the strip. I made a splatter painting on the computer paper. If you use paint, let it dry completely.

3. Fold a section of the strip the width the accordion book will be. I made mine about 3 inches wide.

4. Flip the paper and fold another section the same size as the one in step 3. Repeat this until you've folded the entire strip. If you want a stiff cover, glue a piece of cardboard to the last fold.

5. Before you add the accordion book, prepare the spread. I gessoed the spread but waited to decorate it with paint pens until after I glued the accordion books in place. Decide where you want the book to be and then glue the back of the last page to the spread.

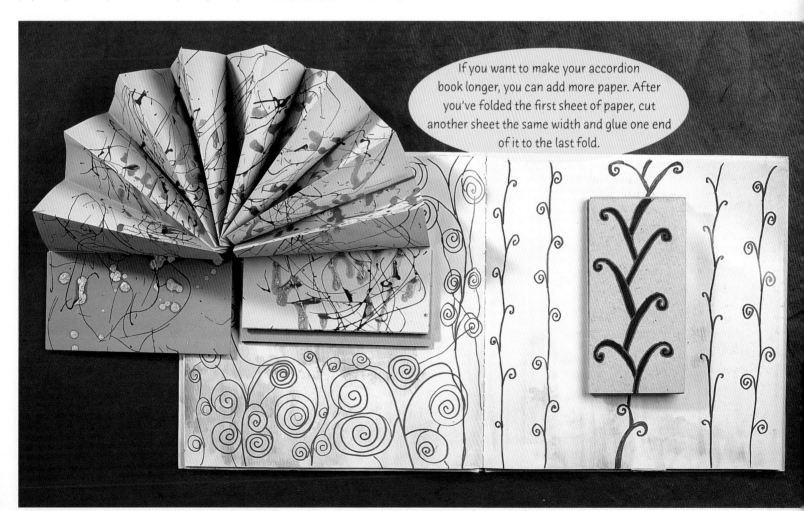

If you want to make your accordion book longer, you can add more paper. After you've folded the first sheet of paper, cut another sheet the same width and glue one end of it to the last fold.

Cover Up

Don't judge a book by its cover—
unless you made the cover.

Collage a Cover

1. Gather the supplies for decorating your cover. I found green paint, thick brown paper, wallpaper samples, a fake nest, and a set of eggs at the craft store.

2. Paint the cover of a hardback book with acrylic paint. Let the paint dry.

3. Cut out the pieces of paper you want to use in your collage. I cut out a brown paper tree branch and wallpaper flowers.

4. Arrange all the pieces of your collage on your cover. Don't forget to decorate the back cover.

5. When you're happy with the arrangement, glue the collage in place. Let it dry.

6. To glue something large and bulky to the surface of your book (like the bird's nest I used), apply a ton of super-strong glue. Hold the object in place while it dries.

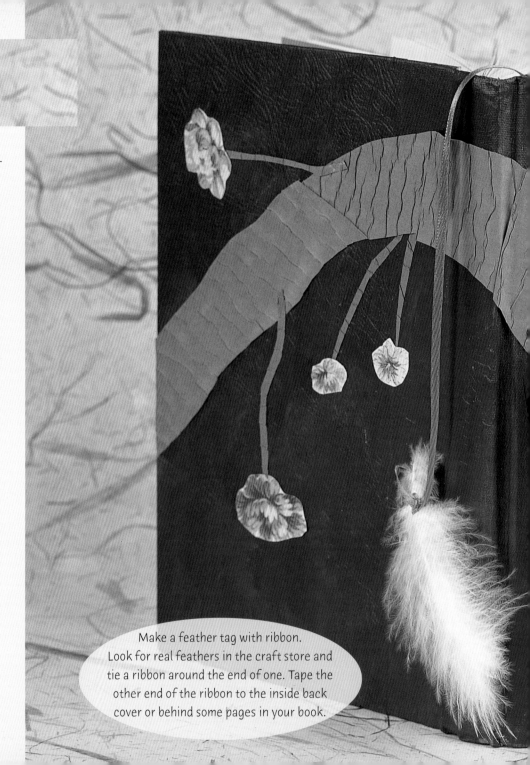

Make a feather tag with ribbon. Look for real feathers in the craft store and tie a ribbon around the end of one. Tape the other end of the ribbon to the inside back cover or behind some pages in your book.

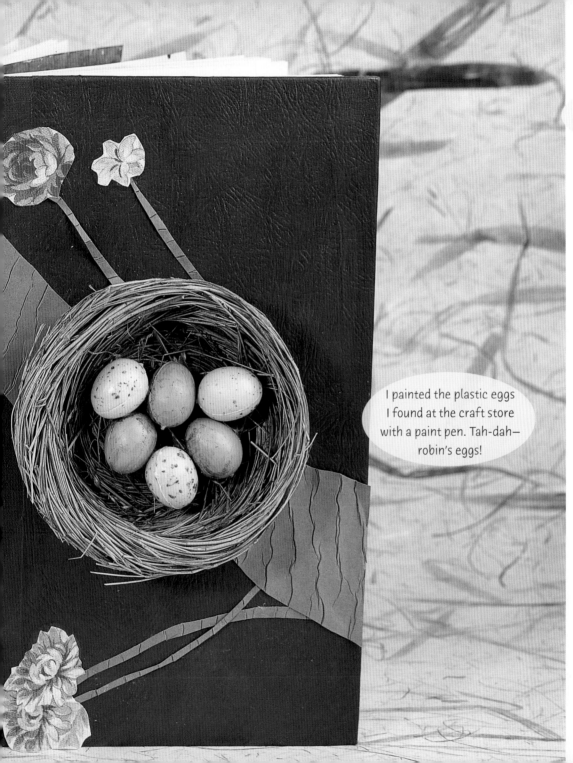

Find flowers in old books, greeting cards, or even fabric.

I painted the plastic eggs I found at the craft store with a paint pen. Tah-dah— robin's eggs!

Photo Collage

Kelly Rae Roberts, a mixed-media artist, wanted to let her dog and cat show their true colors. This is how they would look if they could dress themselves.

Fantastic Plastic Background

1. Paint several layers of acrylic paint over one another. Don't let the paint dry between layers.
2. While the paint is still wet, put a layer of plastic wrap on top of the spread. Squish around the paint beneath the plastic wrap.
3. Let the paint dry completely. (This will take a bit longer than you think, since the paint is covered with plastic wrap.)
4. Remove the plastic wrap.

Add the Photos

1. Pick out large photos. Use old pictures or print copies on your computer.
2. Carefully cut away the background of the picture and dab a bit of glue around the edge. Press the photo in place.
3. Collage on top of your photos.

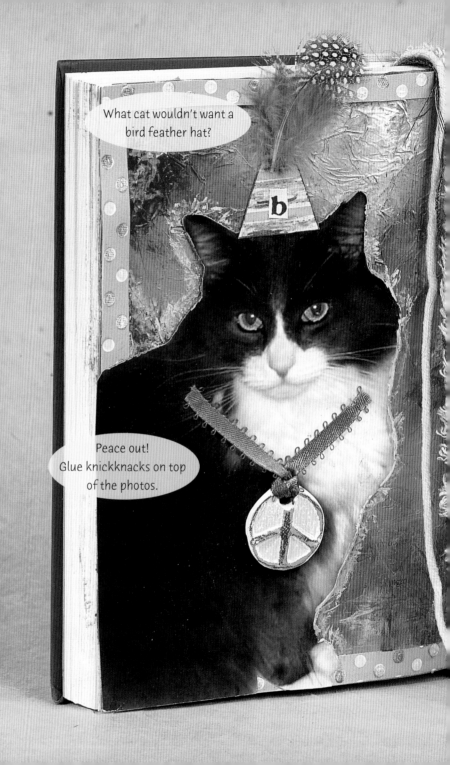

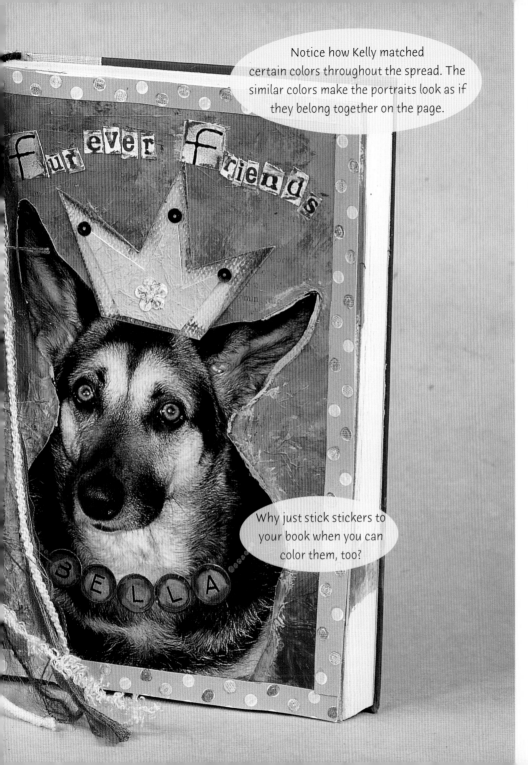

Notice how Kelly matched certain colors throughout the spread. The similar colors make the portraits look as if they belong together on the page.

Why just stick stickers to your book when you can color them, too?

Creating Auras

Wow, these special animals have auras! Kelly created a glowing outline around each of them. Scribble carefully around the edge of your photos with oil pastels or a crayon.

Decorative Bookmark

Cut a variety of ribbons to the same length, gather them in a bundle, and tie a knot at one end to keep them all together. Tape or glue one end of the bundle to the inside back cover of the book. Use it as a bookmark.

Doors

Fill a page with doors that open to wherever you want to go.

Make a Door

1. Cut out a piece of thick paper large enough to cover your image. I made my doors out of rectangles, but you can make them out of any shape you want.

2. Crease one edge of the paper to make a door hinge. Make the fold ½ inch from the edge of the paper.

3. Center the door over the image. Tape or glue the folded edge of the door to the spread.

4. Glue a bead onto the door to make a handle.

5. Decorate the doors with paint pens.

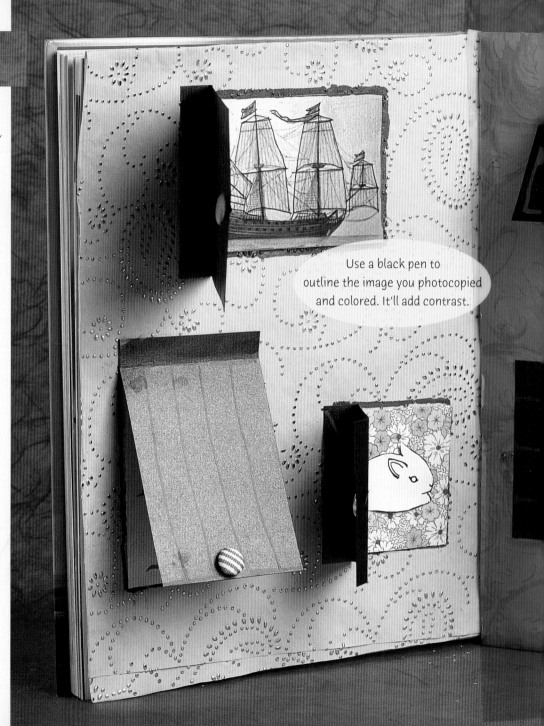

Use a black pen to outline the image you photocopied and colored. It'll add contrast.

Stamp something (see page 22). Then color around it.

Draw an image by hand with a black pen and then color it in.

Create a bit of texture by placing your drawing on a rough surface and coloring it in. I used the woven cover of a book.

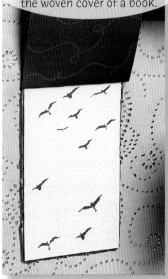

Poetree

Words do grow on trees. There are pretty words, silly words, fancy words...

Bodacious Backgrounds

1. Color some gesso (see page 79). I made pink gesso. Paint it on the page. Let it dry.

2. Color some gesso a slightly darker color. I made blue gesso. Paint it on, but don't cover the entire page. Let some of the original layer of gesso show through. Let the page dry.

3. Mix equal amounts of white craft glue and water in a bowl. Stir them together. Paint the mixture onto the page.

4. Before the glue dries, sprinkle glitter over the page. (It doesn't matter what color glitter you use. You're going to paint over it.) Let the glue dry. Wash out the glue-covered bowl and paintbrush while you wait.

5. Loosely paint over the spread with a darker color acrylic paint. I used brown. Let some of the colors you've already painted show through. Let the paint dry.

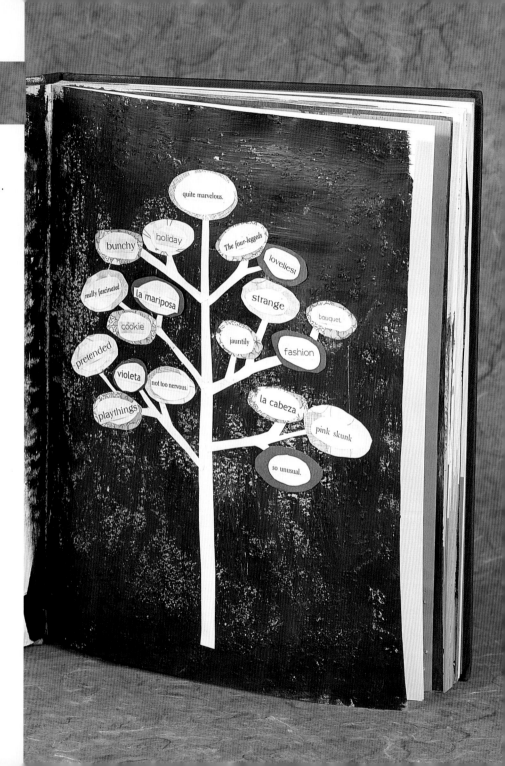

Choose your word. Then cut leaf shapes from colorful paper. I made oval leaves.

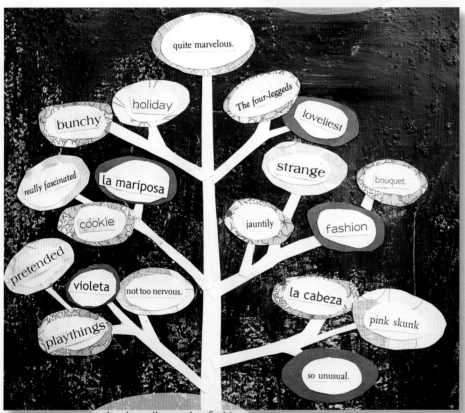

I glued smaller ovals of white paper to the decorative papers to help the words stand out.

Constuct a Poem

1. Thumb through old magazines, letters, and books, looking for words you like. Cut out the words. Glue them to colorful papers.

2. Know what words you want to use? Type them up on a computer using fonts and sizes you like, and then print the words out. Cut them out and make them into leaves.

Branching Out

1. Choose a color of paper that goes with your background. Make sure this paper is plainer than the paper you want to use as leaves. Cut a tree trunk out of it.

2. Glue the tree trunk to the page in your book.

3. Cut branches out of the paper. Experiment with the placement, but don't glue them yet.

4. Make your word leaves and add them to the ends of the branches. Add more forks and branches if you need to.

5. When you're happy with the arrangement, glue everything in place.

Windows to Your World

Fill a book with framed pictures and you've got your own art museum.

Frame It

1. Use a ruler to measure the picture you've chosen. Draw a rectangle that size on a piece of paper. I used fancy white cardstock. Draw a slightly smaller rectangle inside the first.

2. Cut out both rectangles. Use a craft knife to cut out the inside one. If you'd like to add bars to your window, cut out two long, skinny strips, each a bit longer than the inside of the rectangle.

3. Tape or glue the picture to the spread (unless it's already a part of the spread). Put the bars on top of the window in the shape of a plus sign. Glue them in place.

4. Center the frame on the picture and glue it in place.

Want instant gratification? You can find pre-made window frames in the scrapbook aisle of the craft store.

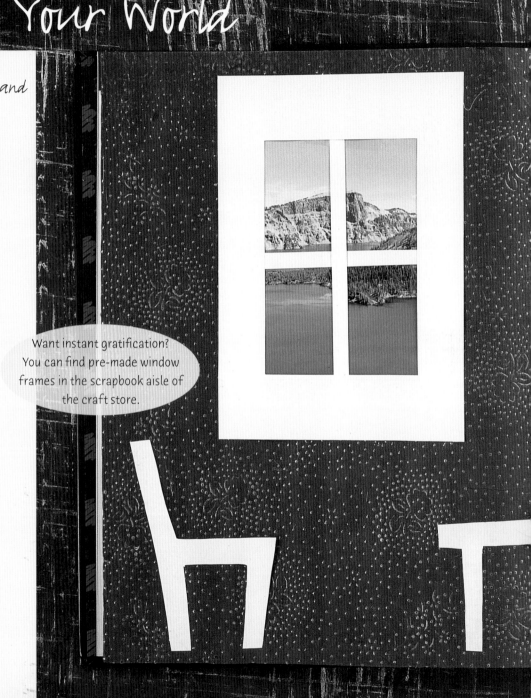

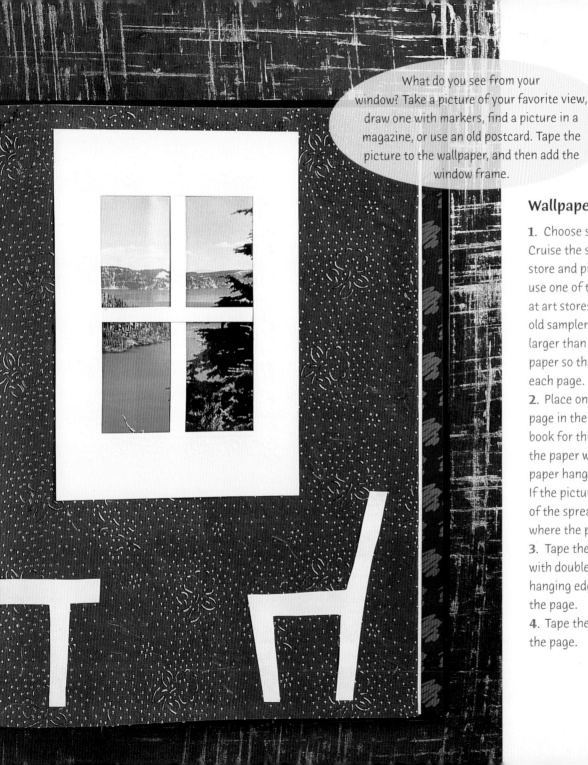

What do you see from your window? Take a picture of your favorite view, draw one with markers, find a picture in a magazine, or use an old postcard. Tape the picture to the wallpaper, and then add the window frame.

Wallpapering Made Easy

1. Choose some paper for your wallpaper. Cruise the scrapbooking aisle at the craft store and pick out the heaviest papers, or use one of the thick specialty papers sold at art stores. I used real wallpaper from an old sampler book. Make sure the paper is larger than a spread in your book. Cut the paper so that you have two pieces: one for each page.

2. Place one sheet of paper over one page in the book. You can use any type of book for this project. Line up the edge of the paper with the gutter. Let the excess paper hang over the edges of the page. If the picture you want to frame is a part of the spread, cut a hole in the wallpaper where the picture will go.

3. Tape the back of the paper to the page with double-stick tape. Fold over the overhanging edges, wrapping them around the page.

4. Tape the folded edges to the back of the page.

Nature Journal

Relive your adventures in the wild with a collage made from the things you found there.

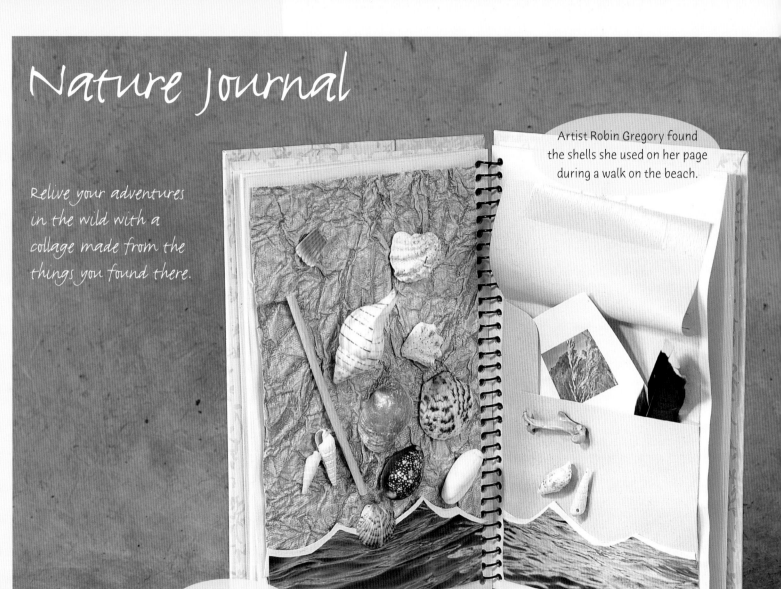

Artist Robin Gregory found the shells she used on her page during a walk on the beach.

Make waves from photos of water.

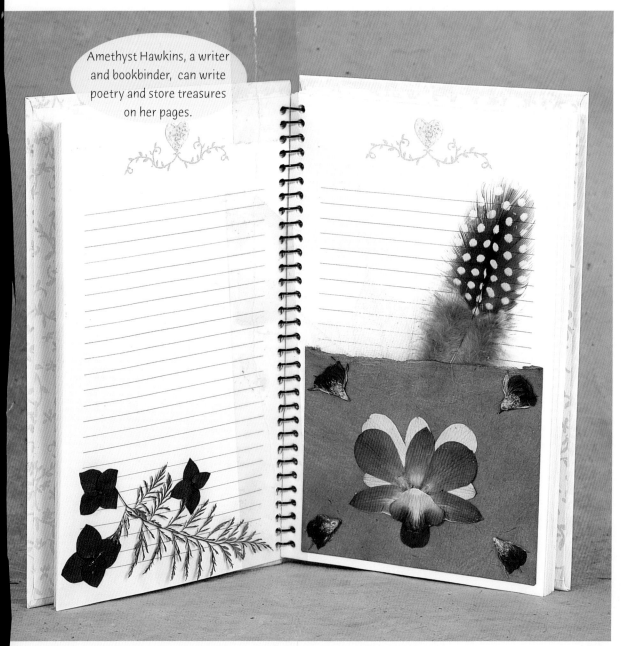

Amethyst Hawkins, a writer and bookbinder, can write poetry and store treasures on her pages.

Pressing Flowers

1. Collect flowers and leaves while they are still alive.

2. Press them between the pages of a heavy book for a week.

3. Glue them to the page with a glue stick.

Make a Pocket

1. Cut a piece of paper a little bit larger than you want your pocket to be.

2. Fold a ¼-inch flap along one side of the paper. Repeat on the other side and on the bottom edge. These flaps will be the sides and bottom of your pocket.

3. Glue the flaps to the page with a glue stick.

4. Decorate the pocket with pressed flowers. Glue them in place.

5. Store your treasures inside the pocket.

Amethyst Hawking wanted a little more bang for her book, so she made some simple books to put inside it.

Simple Stab Binding

1. Find an old book to put your handmade books inside of. The books you make need to be smaller than this book. Amethyst wanted to make a large handmade book so she used an old geography textbook.

2. To make your first book, pick out a piece of thick paper for the cover. Choose thinner paper for the pages. Decide how many pages you want inside your book.

3. Cut the cover paper you've chosen for the cover into a rectangle as tall as you'd like the book to be and twice as wide. (Remember, it has to fit inside the book you chose in step 1.)

4. Cut the paper for the inside pages into rectangles slightly smaller than the cover paper. Cut half as many of these as the number of pages you want. (You're going to fold them in half, so each piece will make two pages.)

5. Stack the papers, with the cover paper on the bottom. Hold down one edge of the stack and fold over the other. Your stack of paper should look like a book now. Crease the spine.

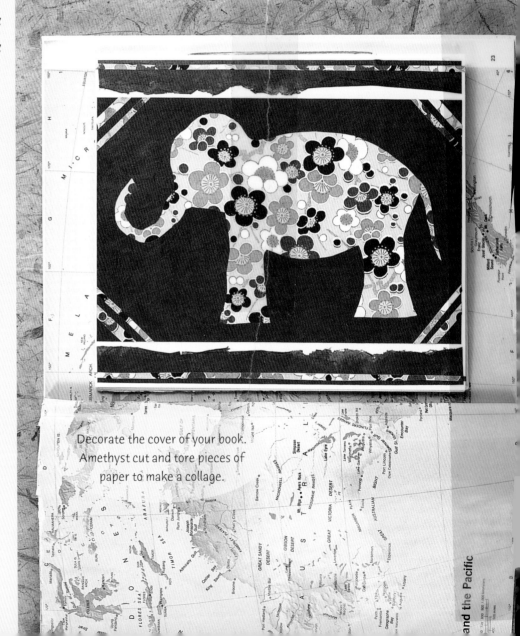

Decorate the cover of your book. Amethyst cut and tore pieces of paper to make a collage.

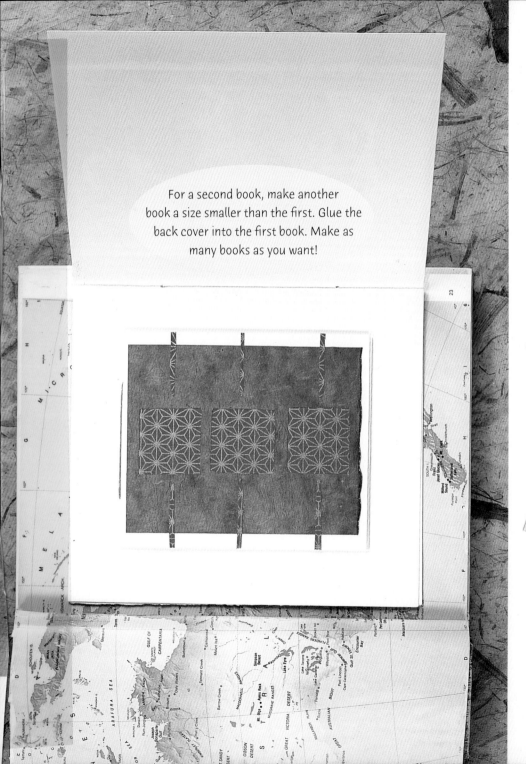

For a second book, make another book a size smaller than the first. Glue the back cover into the first book. Make as many books as you want!

6. Unfold your book. Use a sharp tool, like a nail or thick needle, to poke two holes in the crease. Put one near the top and the other near the bottom. Make sure the holes go through all the pages.

7. With a needle and thread, sew through the holes you made. Pull the thread tight and tie the ends together.

8. Pick a page in the old, large book where you want to put your handmade book. Glue the back cover of the handmade book onto the spread.

Ribbon Weave

Transform a simple cutout into a dazzling picture by weaving scraps of paper and ribbon into the page behind it.

Weaving

1. Place a piece of cardboard behind the page you want to weave into. If you want the weaving to show through a cutout, make the cutout first (see page 71). You'll weave into the page beneath it.

2. Using a ruler and a pencil, draw a series of parallel lines across the page. Don't draw them all the way to the edges of the page. I made horizontal lines.

3. Cut the lines with a craft knife. Don't cut all the way to the edge of the page!

4. Cut strips of paper and weave them through the cuts you made. Weave under one cut and over the next. Tape the ends of the paper strips to the page so they don't move.

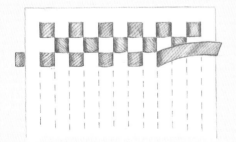

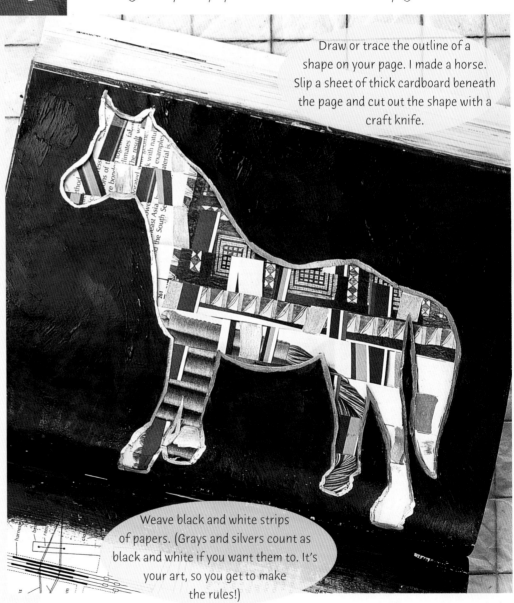

Draw or trace the outline of a shape on your page. I made a horse. Slip a sheet of thick cardboard beneath the page and cut out the shape with a craft knife.

Weave black and white strips of papers. (Grays and silvers count as black and white if you want them to. It's your art, so you get to make the rules!)

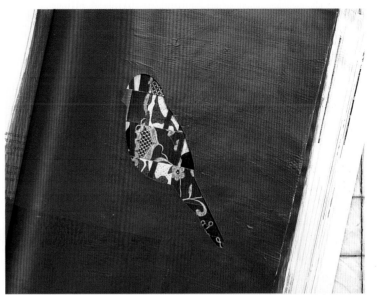

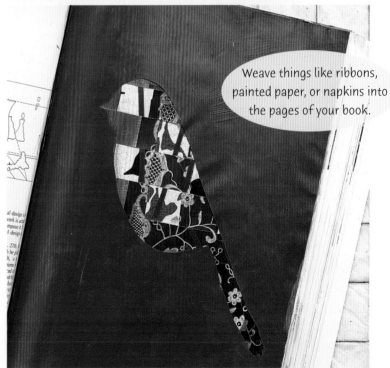

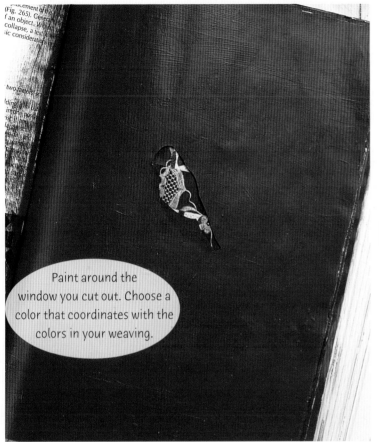

Paint around the window you cut out. Choose a color that coordinates with the colors in your weaving.

Weave things like ribbons, painted paper, or napkins into the pages of your book.

Seeing Triple

1. Make a cutout that gets bigger and bigger as you flip the pages. Use the same outline on each page. I cut out a bird. You can do this on any four pages in your book.

2. Start with the smallest outline. Draw it on the middle of the page. Put a piece of heavy cardboard beneath the page. Carefully cut it out with a craft knife.

3. Draw the outline, slightly larger, on the next page. Put a piece of heavy cardboard beneath it and cut it out.

4. Draw the largest outline on the next page. Put a piece of heavy cardboard beneath it and cut it out.

5. Make a paper weave on the page that shows through.

Penny Painting

Here's a way to make your artwork more valuable: Put money in it!

Penny Patterns

1. Use a board book for this project. The sturdy pages will be able to hold the weight of the pennies. If you want to use a regular book, reinforce the pages before you start (see page 10).

2. Prepare the pages of the board book (see page 9). Paint the spread with acrylic paint, or decorate the background however you want. Let it dry.

3. Arrange a handful of pennies on the spread. Experiment with different placements and think about what color you'd like to paint each one.

4. Spread your pennies on a piece of newspaper. Use acrylic paint and a small paintbrush to paint the top of each one. Don't forget to do the edges!

5. After the pennies are dry, glue them to the spread. Since they're heavy, use super glue or a glue gun. Let them dry.

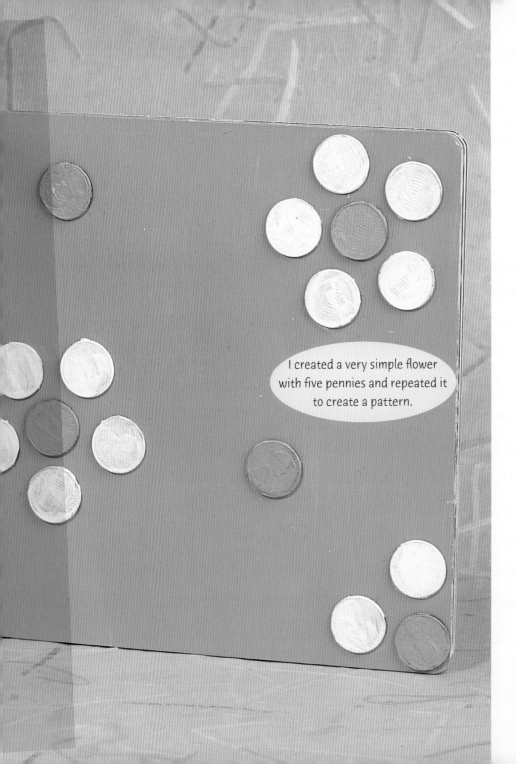

I created a very simple flower with five pennies and repeated it to create a pattern.

Removing Pages

1. Gluing pennies in a book takes up lots of space. It's going to be hard to close it properly. It probably won't close completely, but you can make it better. If you didn't use a board book for this project, you can follow the instructions on page 11 to remove pages.

2. Cover your workspace with a piece of cardboard.

3. Flip to a page in the board book a few pages away from where you glued the pennies. This is the page you'll remove.

4. Put the board book on top of the cardboard, with the page you're going to remove laying flat. Make sure there aren't any other pages beneath it.

5. Use a box cutter to carefully cut out the page. Don't cut into the binding.

6. Repeat steps 3 through 5 to remove as many pages as you need to.

In Stitches

Sewing isn't just for clothes anymore. Ted Harper used funky stitches to transform this spread.

Stitching

1. Individual book pages are too thin to stitch through—they'll rip. So before you thread your needle, thicken the pages. Glue at least five pages together on each side of the spread. Let the glue dry. Don't forget to put waxed paper between the pages you glue and the rest of the book.

2. Arrange your elements on the page. Glue them down. (This will hold them in place while you stitch them.)

3. Thread your needle. Double the thread and tie a knot in the end.

4. From the backside of the glued-together pages, poke the needle through the paper.

5. Stitch around the object. You can make big Xs, stitch parallel lines, or embroider a straight line. Try different techniques.

6. Tie off the thread on the back side of the page.

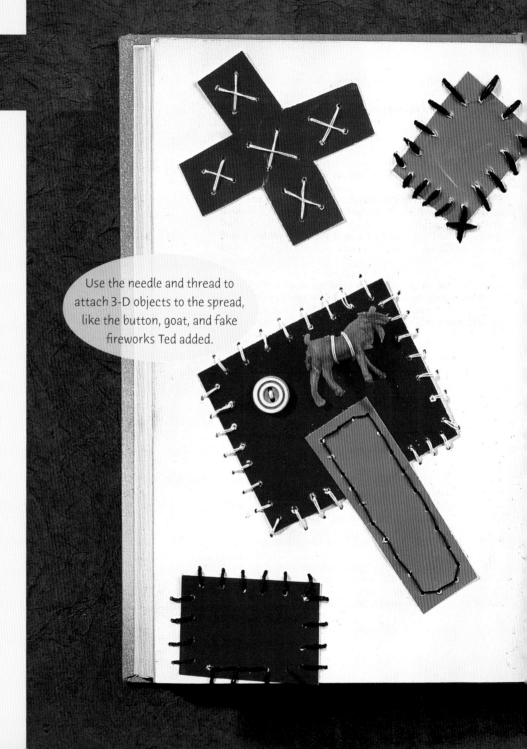

Use the needle and thread to attach 3-D objects to the spread, like the button, goat, and fake fireworks Ted added.

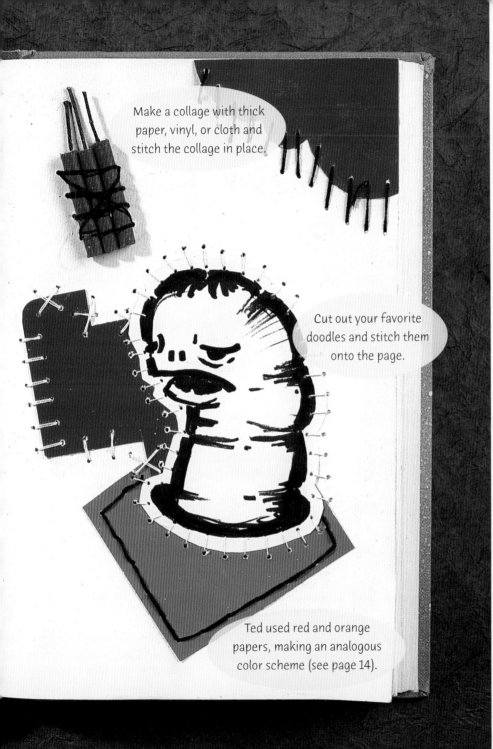

Make a collage with thick paper, vinyl, or cloth and stitch the collage in place.

Cut out your favorite doodles and stitch them onto the page.

Ted used red and orange papers, making an analogous color scheme (see page 14).

Making Explosives

1. Cut a long strip of white construction paper. It should be as wide as the finished firecracker will be tall. Cut a long strip of red construction paper. It should be as wide as the white paper. Ted cut his strips 1 ½ inches wide.

2. Cut a small piece of thick twine. Don't worry about the color—you can paint it later.

3. Mix equal parts white glue and water. Brush the glue onto the strip of white paper.

4. Place the string on the end of the white strip of paper. Let it hang out the end like a fuse. Roll up the strip of paper tightly. Then roll the strip of red paper around the white core.

5. Brush the seam closed with the glue and set it on a piece of waxed paper to dry.

6. Paint the twine green. Let it dry.

Favorite Found Objects

You know all those things you can't part with but don't know where to put? Put them in a book, like artist Ashley Alexander Baxter did!

Adding Pockets

1. Gather photos, stamps, stickers, concert tickets, postcards, letters, notes, pins, buttons, movie stubs…

2. Find or make some envelopes to hold some of your stuff. Ashley used envelopes she had collected, including an old air-mail envelope.

3. Arrange everything before gluing it. Experiment with the placement of the items. When you like how the spread looks, glue everything in place.

4. If you add a lot of things to your page and want your book to close, remove some of the pages (see page 11).

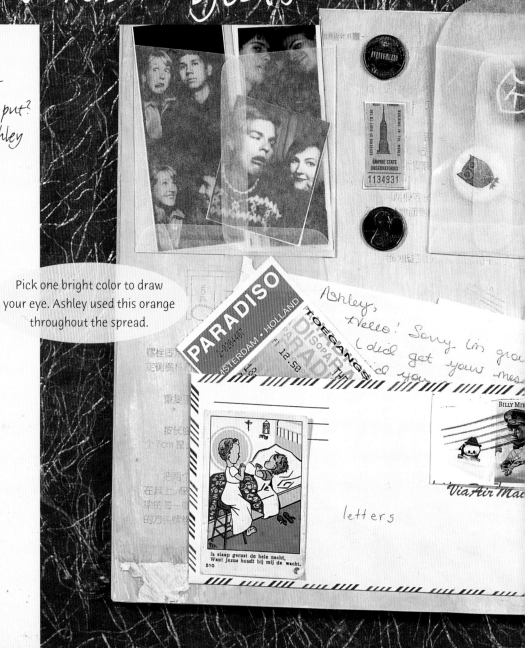

Pick one bright color to draw your eye. Ashley used this orange throughout the spread.

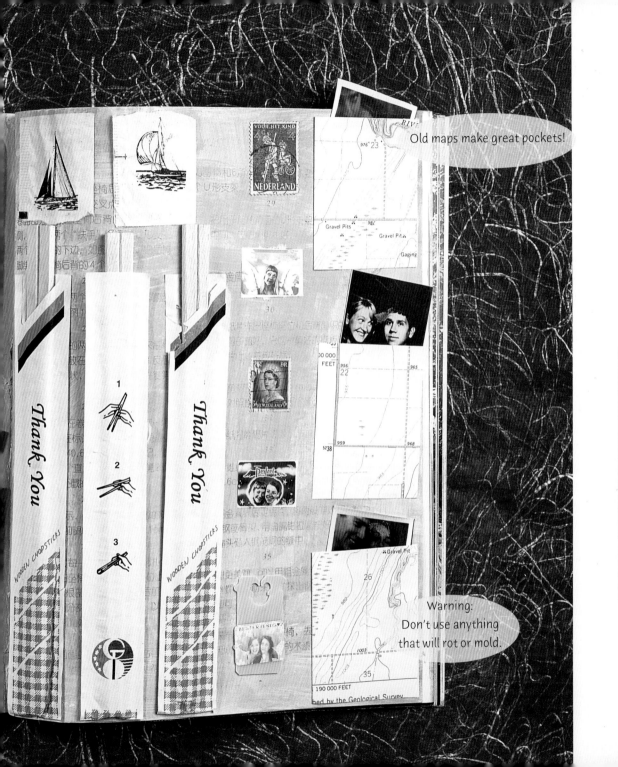

Old maps make great pockets!

Warning:
Don't use anything
that will rot or mold.

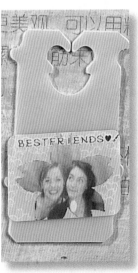

Three-Dimensional Cover

Trim your head out of a photo. Make yourself a brand new outfit.

Make a quirky design with masking tape on your cover. Then paint it. This will add texture to your background.

Don't be shy: Write what you want the world to know!

Create a 3-D cover by collaging objects onto it. Kelly Rae Roberts used photographs, leaves, buttons, and old keys to make this one.

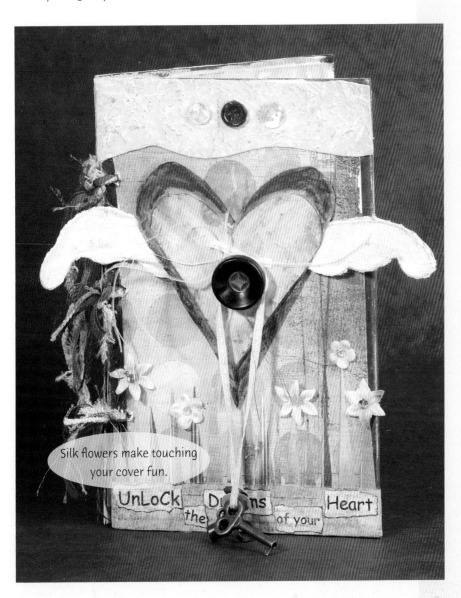

Silk flowers make touching your cover fun.

Make Your Own Wings

1. Bend a piece of flexible wire into a banana shape. Kelly bent scallops into one side of the wire to make her wings.

2. Put a large piece of white tissue paper in front of you. Make sure the tissue paper is large enough to cover the wire shape.

3. In a small bowl, mix together equal parts of white glue and water.

4. Spread the glue mixture over the tissue paper. Place the wire shape on top of the tissue paper, and wrap the tissue paper around the wire shape. Let it dry.

5. Gently tear the remaining tissue paper from around the edge of the wire, revealing the shape of the wings.

6. Glue the wings to your cover. Glue another piece of paper (like the heart Kelly used) on top of the ends. (Then you won't be able to see them!)

Inspiration from the Page

Stuck for an idea? Let the words in your book inspire you.

Pick Your Words

1. Scan the text on a page. Look for descriptive words. I chose words that described colors and objects. Circle the words you find with a pencil.

2. Paint around the circled words. I used acrylic paints. Try watercolors, tempura paint, or gesso if you want. Let the paint dry.

3. Paint the background. I used a color wash (see page 64.)

4. Illustrate the words you've chosen. I drew a moon and an apple. Then I painted the drawings.

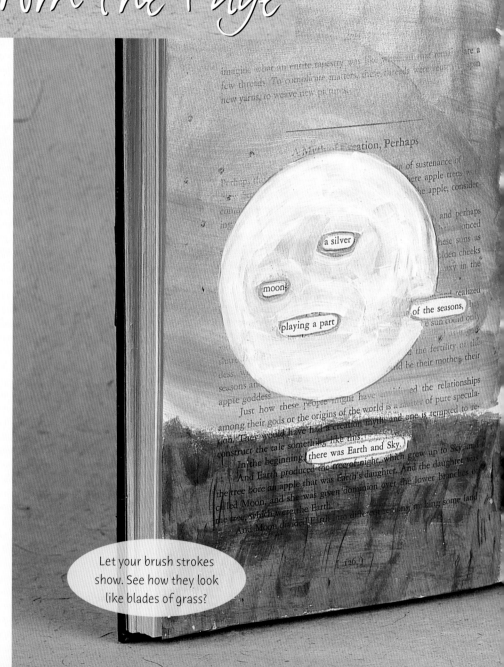

Let your brush strokes show. See how they look like blades of grass?

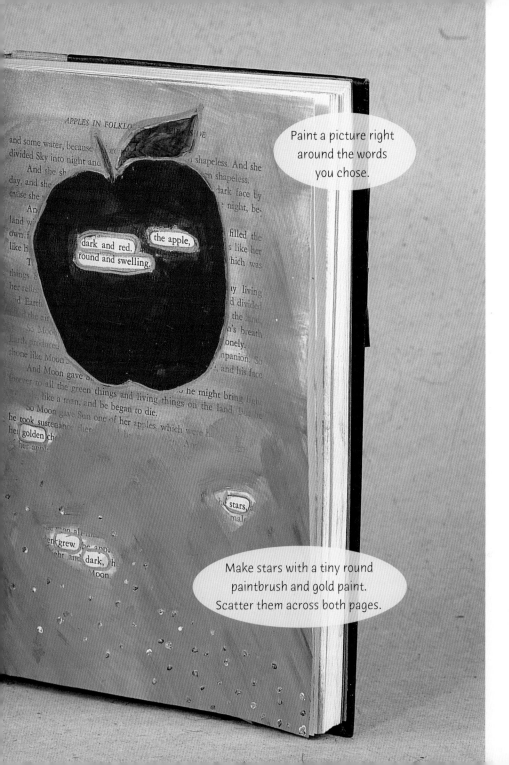

Blending Colors

1. Pick three similar colors: one light, one medium, and one dark. Paint the page with the lightest shade first. Let it dry.

2. Paint the medium shade over about two-thirds of the page so that some of the lightest shade shows through at the top. Let the paint dry.

3. Paint the darkest shade on the bottom third of the page. The light and medium colors should show through at the top. Let the paint dry.

Passing Notes

Who would think to look in a book for the notes you pass to your friends? Be sneaky—use a discarded textbook or reference book.

Color Wash

1. Let some of the original text shine through. Put waxed paper beneath the pages you're going to paint. (This will keep you from soaking the entire book.)

2. Dip your paintbrush in a glass of water. Lightly tap off the excess water and then dip the brush into the paint.

3. Quickly paint on the paper. As you brush the paint onto the page, it will mix together with the water on your brush. This creates a translucent layer of paint that allows the text on the page to show through.

4. After the paint has dried, decorate your spread. I used a paint pen on mine.

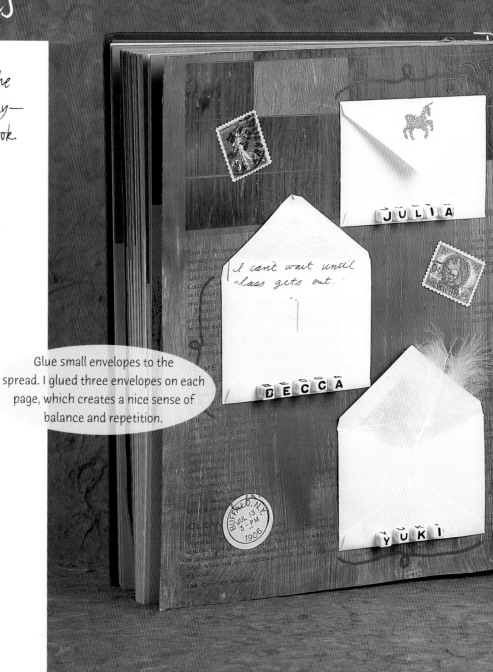

Glue small envelopes to the spread. I glued three envelopes on each page, which creates a nice sense of balance and repetition.

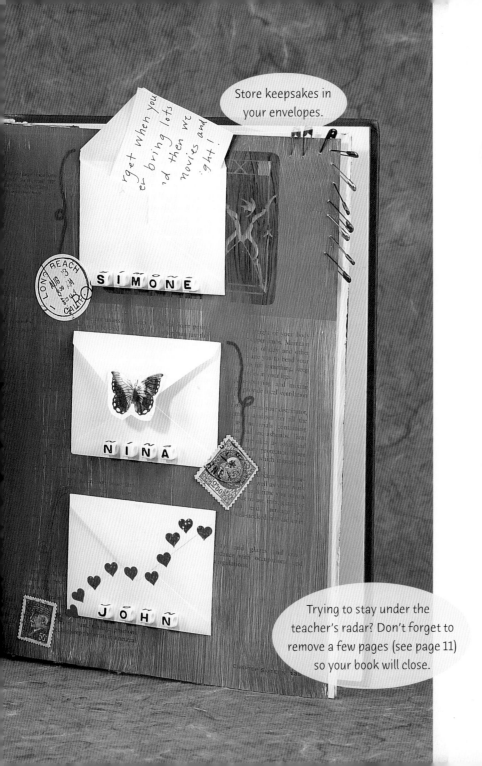

Store keepsakes in your envelopes.

Trying to stay under the teacher's radar? Don't forget to remove a few pages (see page 11) so your book will close.

Tag it! Pierce the edge of the page with safety pins so you can flip to the page quickly. You can find colored safety pins at office supply and craft stores.

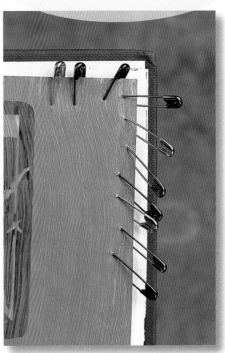

Calendar Book

Jane Hennessy made many months of memories! (Now say that three times in a row.)

Month by Month

1. Find a book that has a calendar in it. If you can't find one, paste a year-long calendar inside the book or write the names of the months on a spread in the middle of the book.

2. Using a craft knife, cut a square around each month. Set aside the square of paper with the month's name on it.

3. Cut a niche beneath each square where you removed the month (see page 87). Glue the pages inside of the niche together. Let the glue dry.

4. Glue the squares with the months on them to a sheet of thick paper. Let the glue dry, and then cut them out.

5. Use white tape (or masking tape) to hinge the months to the niches. Stick one edge of the tape to the month square and the other edge to the top of the niche.

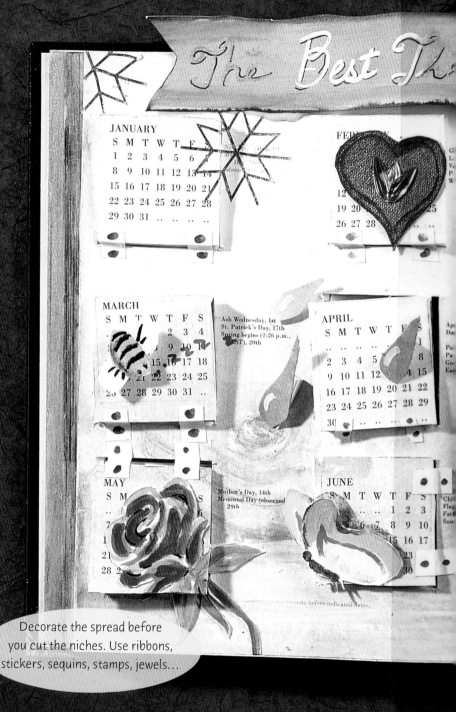

Decorate the spread before you cut the niches. Use ribbons, stickers, sequins, stamps, jewels…

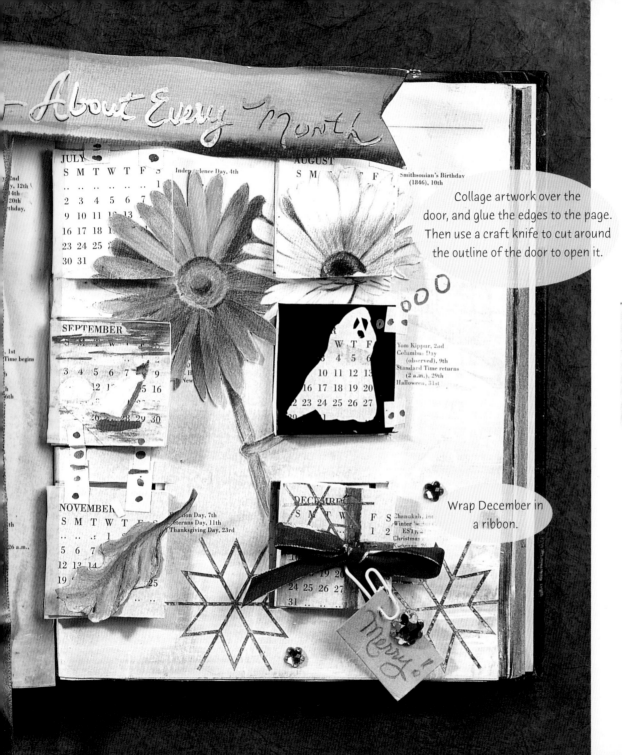

About Every Month

Collage artwork over the door, and glue the edges to the page. Then use a craft knife to cut around the outline of the door to open it.

Wrap December in a ribbon.

Travel Journal Collage

Share a journal with your friends to remember the places you've been. Angela Deane took a trip from New York to London and Paris. E'perfetto! Que bueno! C'est bon!

A Well-Traveled Book

1. To create a travel journal with your friends, find a hardcover book.
2. Each time you go on a trip, take the book with you. Write, draw, collage, or paint about the places you visit and the things you do.
3. Pass the journal on to someone else. Give it to as many friends as you can. The more friends who use it, the more stories and adventures will be recorded on the pages.

The Chrysler building is symbolic, championing the skyline of New York City.

believe it: here, there's high fashion & careers of all kinds: acting, dancing, banking, even dog walking.

But the great thing about my home is the pursuit of Being Yourself.

Select words that remind you of your trip, and then carefully brush gesso around them. Write words between them to create sentences.

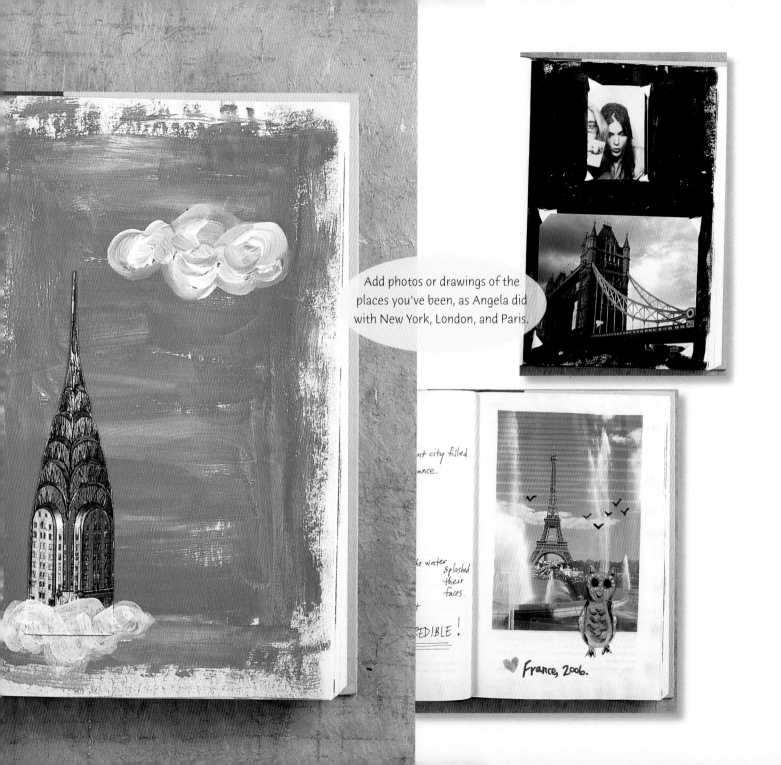

Add photos or drawings of the places you've been, as Angela did with New York, London, and Paris.

...nt city filled
...ance.

...he water splashed
their faces.
...t
...REDIBLE !

♥ France, 2006.

Travel Journal Landscape

Decorate your spread in the travel journal with a landscape that shows where you've been.

Collage a Landscape

1. Gather two or three different types of paper. Decide which one you want to use for the background, middle ground, and foreground (see page 26).

2. Glue the background paper to the page. Wrap it around the edge of the page if you want.

3. Cut the middle ground paper into a horizon. I used tree paper and cut the top of the sheet into the shape of a mountain range. Glue it in place.

4. With the last type of paper, cut out a shape, like the airplane shown here, and glue it onto the collage.

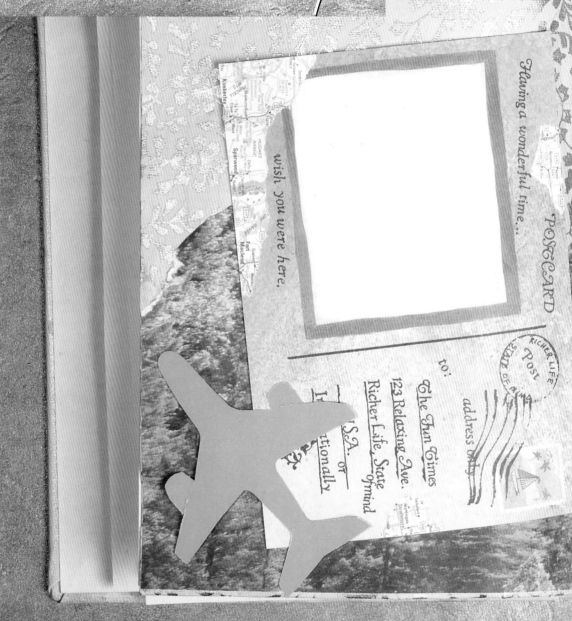

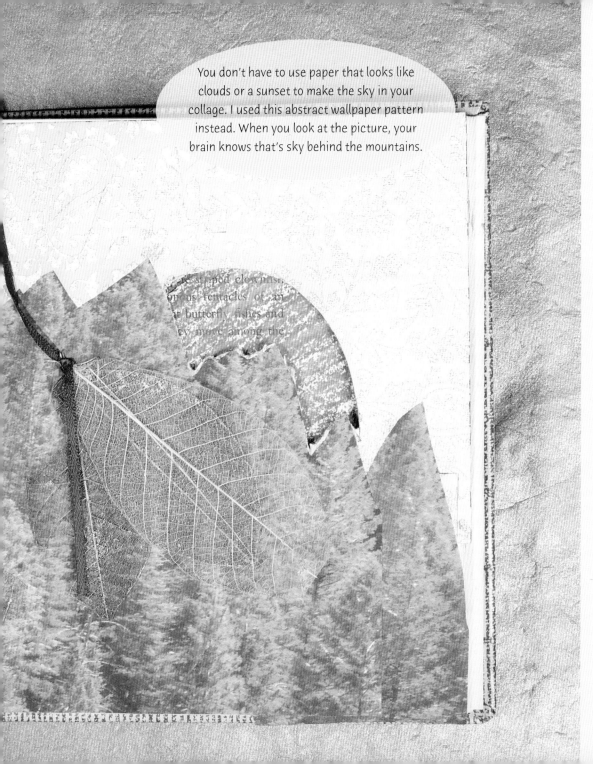

You don't have to use paper that looks like clouds or a sunset to make the sky in your collage. I used this abstract wallpaper pattern instead. When you look at the picture, your brain knows that's sky behind the mountains.

Make a Cutout

1. Glue the back of the page that you're going to cut a cutout in to the page behind it. This will make the page stiff enough to hold the window. Let the glue dry.

2. Draw the shape of the window with a pencil. I made mine look like the Sun.

3. Put a piece of cardboard behind the page and use a craft knife to cut out the window.

4. Color the page that shows through the window with oil pastels or crayons. I let some of the text show through.

Got Game?

Turn an old phone book into a checkerboard. Andrew Bowers hollowed out his book so he could store the pieces inside.

Pick a patterned paper for your contrasting squares or use a picture from a magazine. It doesn't need to be a solid color. (Paint the squares if you prefer.)

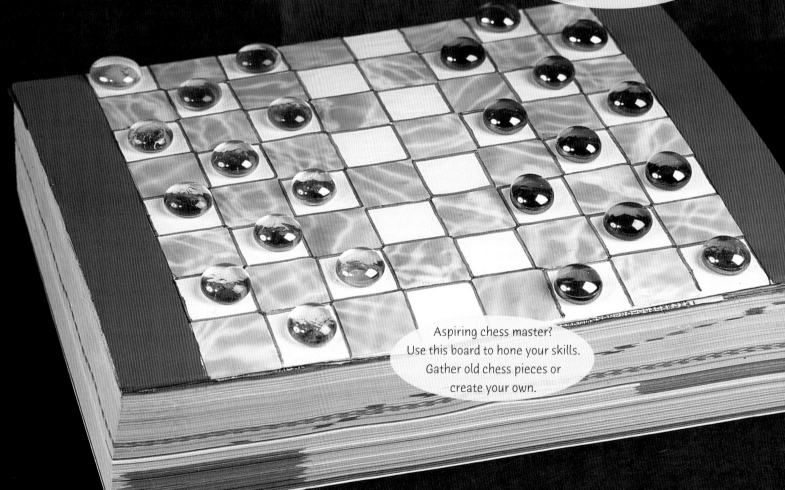

Aspiring chess master? Use this board to hone your skills. Gather old chess pieces or create your own.

Making the Game

1. Place the phone book on a piece of thin cardboard, like an old cereal box. Trace around the phone book with a pencil. Cut out the cardboard on the inside of the line you traced. Glue it to the cover of the phone book. (This will strengthen the cover so it will support your board.) Let the glue dry.

2. Gesso or paint the cover a light color. Andrew wanted his background to be white. Let the paint dry.

3. Draw an 8-inch square on the center of the phone book. This is the game board. Use a ruler and a pencil to draw a line across the board at every inch. Do the same in the opposite direction, making the checkerboard grid.

4. Cut 32 squares from a piece of paper. Each piece should be a 1-inch square. (A paper cutter will make this job a snap.) Andrew used blue paper.

5. Glue the paper pieces to every other square on the game board. Let the glue dry.

6. Outline the squares with a permanent marker.

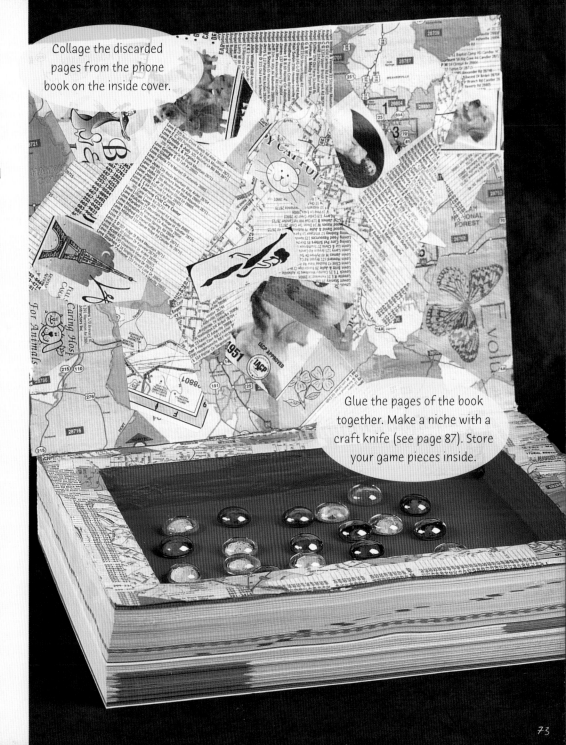

Collage the discarded pages from the phone book on the inside cover.

Glue the pages of the book together. Make a niche with a craft knife (see page 87). Store your game pieces inside.

Picture Frame

Kelly Rae Roberts transformed this book into an original picture frame that stands on its own.

Frame It

1. Open a hardback book to its center. Apply gesso to both pages and let it dry.

2. Place the photos you want to frame on the spread and lightly trace around them with a pencil. Set them aside.

3. Decide how many cutouts you want to have framing your picture. Kelly cut three windows into the page, each smaller than the previous one, to make a border around each photo.

4. Count 10 to 15 pages beneath one of the pages you gessoed. Slip a piece of heavy cardboard between the stack of pages and the rest of the book. Use a craft knife to carefully cut out a rectangle, making the first window. (If you're only making one window, be sure to cut it at least ¼ inch inside the outline you drew for the picture.)

5. Repeat step 4 until you've cut as many rectangles as you like. Make each rectangle ¼ inch smaller than the previous one.

6. Decorate your spread. Kelly used stickers to spell out words.

7. Glue the edges of your photos to the last page of your cutouts. Brush glue along the outer edges of the pages. This will help your book stand up.

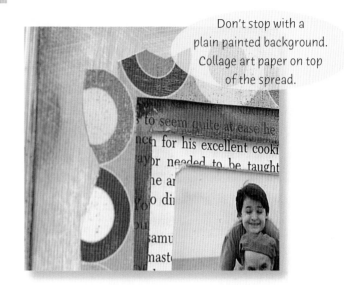

Don't stop with a plain painted background. Collage art paper on top of the spread.

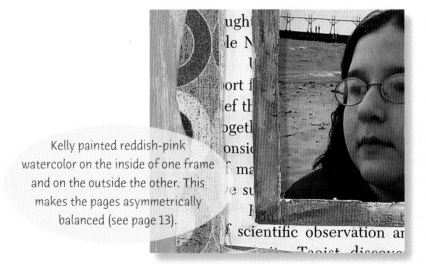

Kelly painted reddish-pink watercolor on the inside of one frame and on the outside the other. This makes the pages asymmetrically balanced (see page 13).

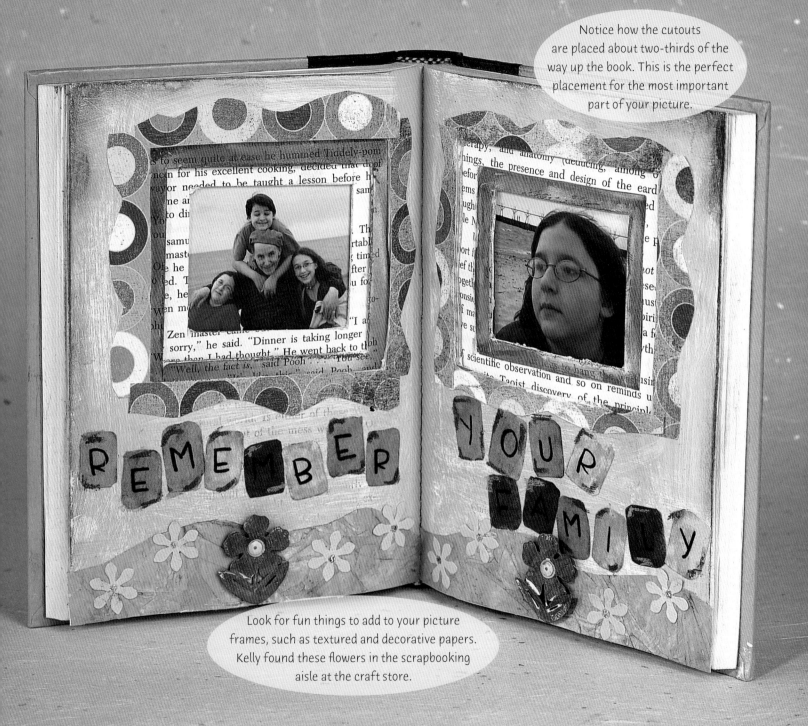

Notice how the cutouts are placed about two-thirds of the way up the book. This is the perfect placement for the most important part of your picture.

REMEMBER YOUR FAMILY

Look for fun things to add to your picture frames, such as textured and decorative papers. Kelly found these flowers in the scrapbooking aisle at the craft store.

Pop-Ups

All it takes is a small strip of paper to make your artwork pop off the page.

Simple Pop-Ups

1. Draw some characters on thick white cardstock. You could trace your favorite illustrations or just cut them out and glue them onto the thick white cardstock. I drew some manga characters.

2. Color in the characters. I used colored pencils and outlined the characters with a thick marker.

3. Cut out the characters and arrange them. Let them overlap a bit if you want.

4. Decide which characters you want to pop out. Glue the other parts of your drawing to the spread.

5. For each pop-up character, cut a long strip of cardstock. I used pieces about ¼ inch wide and 5 inches long. Make yours narrower if your character is smaller, and longer or shorter depending on how far you want it to pop up.

6. Fold the strip back and forth in an accordion fold (see page 36).

7. Glue one end of the strip to the back of the pop-up. Glue the other end to the page.

8. Repeat steps 5 through 7 to make other characters pop up.

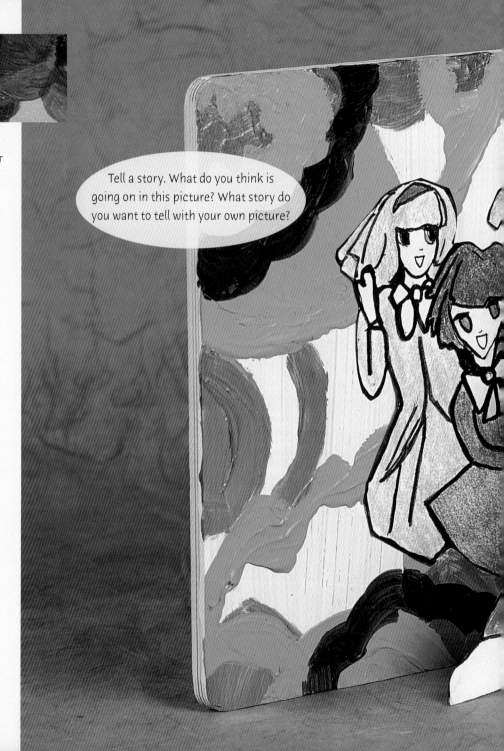

Tell a story. What do you think is going on in this picture? What story do you want to tell with your own picture?

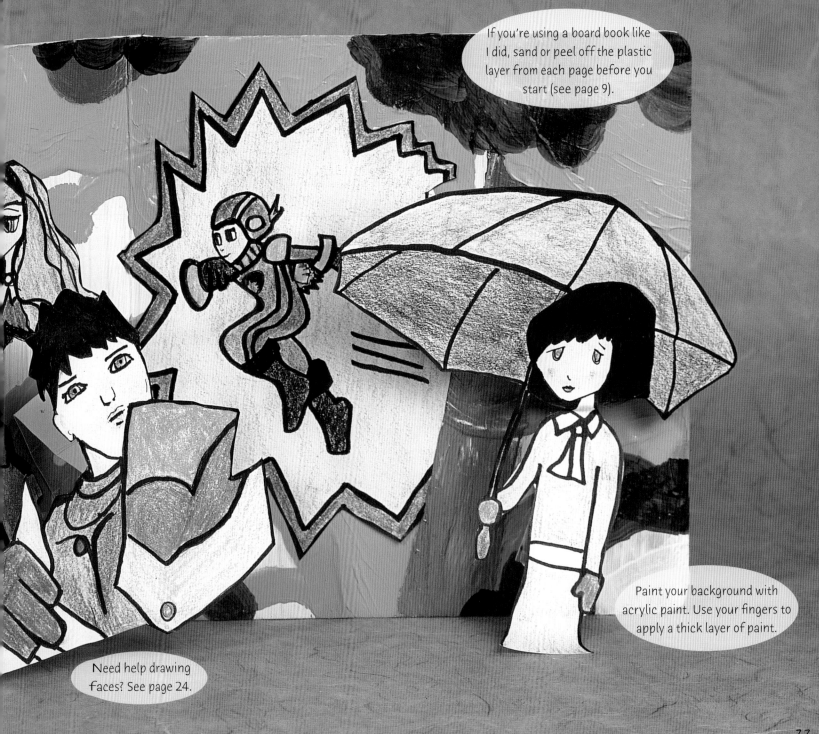

Best Friends Collage

A book is the perfect place to store all those old notes, letters, and postcards from your friends for safekeeping. Ashley Alexander Baxter made this one to remember her friends in Albuquerque.

Don't like the picture on last year's school ID? Who does? Collage over it. If you use enough glue, no one will be able to use it to blackmail you later.

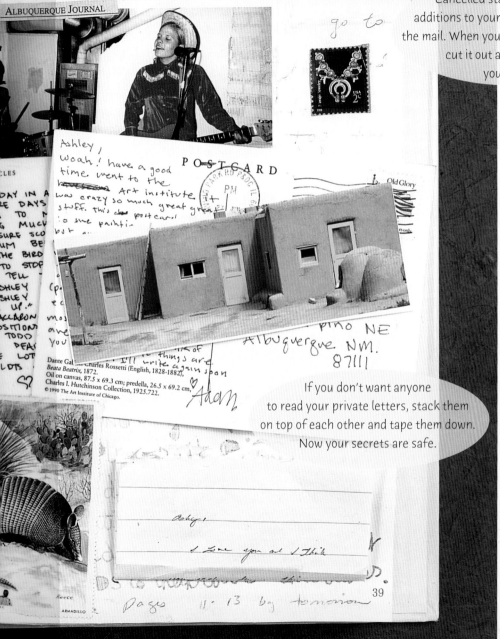

Cancelled stamps make great additions to your pages. Rifle through the mail. When you find a fantastic stamp, cut it out and glue it onto your page.

If you don't want anyone to read your private letters, stack them on top of each other and tape them down. Now your secrets are safe.

Coloring Gesso

1. Tired of boring white gesso? You can make it any color you want. Put some gesso in a small bowl. Make sure you have enough gesso to cover your entire spread. If you run out, you'll have to mix more of the same color, which can be tricky.

2. Add color to your gesso. You can use watercolor or acrylic paint to do this. Add a little bit of color at a time and mix it in with a fork. If you need to make it lighter, add more gesso.

3. When you have the color gesso you want, paint it onto the spread.

4. Store leftover gesso in a plastic container with an airtight lid. Wash the bowl and fork you used with hot soapy water.

Secret Box

This box is so well camouflaged, even you might forget it's there. Andrew Bowers used an old textbook to make this project.

Carving a Secret Box

1. A thick hardcover book works best for this project. Open the book. Find a picture that you can cut around. The picture will become the lid of the box, and your eye will be so busy looking at the picture you won't notice the teeny tiny cut marks around it.

2. Being oh-so precise, cut the picture from your book with a craft knife. Making sure it doesn't wrinkle, glue the picture to a thin piece of cardboard. (An old cereal box works well for this.) This will be the box's lid. Set it aside.

3. Cut a box in the pages beneath the picture with a craft knife or box cutter until the box is as deep as you want it to be. Be careful and patient. Give yourself a few days to finish this step.

4. Coat the walls of the box with several layers of craft glue. Let the glue dry. Don't coat the outside edges of the book with glue.

5. Paint the inside of the box with acrylic paint. Let the paint dry.

6. Trim the excess cardboard from the lid of the box. Place it over the box.

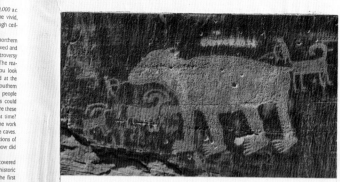

Leave the outside edges of the pages unglued. Gluing them together will give away your secret.

to have lasted from 30,000 B.C. until about 10,000 B.C. There you will find these earliest works—the vivid, lifelike pictures of animals painted on the rough ceilings and walls of caves.

In caves found in southern France and northern Spain are numerous paintings, so well preserved and skillfully done that they caused great controversy among scholars when they were discovered. The reason for this controversy becomes clear if you look closely at one of the animal paintings found at the cave of Lascaux in the Dordogne region of southern France (Figure 6.3). Is it possible that cave people working with the most primitive instruments could have produced such splendid works of art? Are they the work of skilled artists from a more recent past? Perhaps, as some have suggested, they are the work of tramps or shepherds who took shelter in the caves. On the other hand, if they are truly the creations of prehistoric artists, why were they done and how did they survive?

Today scholars agree that the paintings discovered at Lascaux and at Altamira are the work of prehistoric artists. However, it is unlikely that they are the first works of art ever created. They are too sophisticated for that. No doubt they were preceded by hundreds, perhaps thousands, of years of slow development about which nothing is known still. Of course, this does not keep people from speculating about how art may have started . . .

Deep inside the cave, the man sat down for a moment to rest. After several minutes, he raised his torch high above his head to examine his surroundings. Curiosity had driven him to explore deeper into the cave than he had ever ventured before, even though he and his family had lived at the mouth of the cave for many weeks. The light of his torch cast long shadows on the rough stone walls of the cave, and the man noticed that some of the shadows looked like the animals he hunted daily in the fields. Idly, he bent down and picked up a piece of soft stone and walked to a place on the wall where the surface seemed to swell outward like the round body of an animal. With a few awkward strokes of stone, he added legs and then a head to the body. Finished, he stepped back to admire his work. It was crude, but it did look something like a bison. The man, standing alone in the dark, silent cave, suddenly became frightened by the strange image he had created on the wall. He turned and made his way back to the mouth of the cave. It would be many days before he gathered enough courage to return to the mysterious drawing on the wall, and he would take others with

During prehistoric [t]imes [...] limited to the drawing [...] due to the prehistoric [...] for food. The painti[ng ...] played a part in some [...] help them in the hu[nt ...]

Of course, hunting [...] different from what it is today. Prim[itive ...] clubs were the only weapons known, and these had [to] be used at close range. This made the hunting of large game very dangerous. Often hunters were seriously injured or killed. When this happened, the rest of the family was in danger of starving.

him to see it. They would all agree that what he had done on the wall of the cave was magic . . .

While this story is imaginary, it is quite possible that prehistoric cave painting started this way. Because these paintings of animals were done deep inside caves, far from the living quarters near the entrance, scholars now feel that they must have had something to do with magic rituals.

Use of the Paintings in Hunting Rituals

Before taking up their clubs and spears, prehistoric hunters may have turned to magic to place a spell over their quarry. This was intended to weaken it and make it easier to hunt. The magic may have involved a ceremony in which an image of the animal was painted on the wall or ceiling of the cave. They probably believed that by drawing a lifelike picture of an animal they were capturing some of that animal's strength and spirit. This would make it easier for them to find and overcome the real animal in the fields. These prehistoric people may have thought that the animal could be weakened even more if, during the magic ceremony, they frightened it or struck the painted image with their spears and clubs. The presence of spears shown penetrating the bodies of some [...] ritual did for prehistoric hunters.

[left margin fragments:]
[...]s can be used
[...]ge a work of
[...]re helpful in
[...]s than others.
[...]rations to see
[...]re your study
[...]rt-history op-
[...]ages 97–104.

[...]storians and
[...]uman devel-
[...] that it was
[...]ousand years
[...]man achieve-
[...]e early dates
[...]hey are the

[...]ts produced
[...]d by several
[...]according to
[...]other way is
[...] found near
[...]ns maintain
[...]4. After the
[...]radioactivity
[...]radioactivity
[...] instance, it
[...]ese objects
[...]tings are lo-
[...]approximate
[...]ever, dating
[...]nd this may
[...]revise some

[...]start some-
[...]to a period
[...]one Age, or
[...]od believed

[right column fragments near middle:]
school pe[...]
music serves the same [...]
and courage in team members just [...]

shape Your Book

One of the most radical things you can do to a book is to change its shape. Andrew Bowers is crazy about riding his bike, so he made this book into a bike.

Don't cut into the spine of the book too much. If you do, the pages won't hold together.

This project, like the niche-cutting projects, requires care and patience. If you aren't 100 percent confident that you can make these cuts without hurting yourself, ask an adult to give you a hand.

Giving It Shape

1. Find a board book for this project. Use a permanent magic marker to draw the outline of the shape you want on the cover.

2. Open the book and lay the cover flat on a sturdy work surface. (Make sure it's a place you don't have to worry about damaging.) Use a box cutter to slowly cut along the outline you've drawn on the cover. This takes a firm and steady hand, so go slowly and take breaks.

3. After you've cut the cover, close the book. Trace the cover's new shape onto the page beneath with the permanent marker.

4. Repeat steps 2 and 3 on all the pages in your book.

5. To prepare the pages of your book for altering, tear or sand off the plastic coating from the cover and each page (see page 9). Gesso the pages. Let them dry.

6. Sketch your illustrations onto the gesso with a pencil. Figure out what other drawing will fit inside the shapes you've made. Andrew drew binoculars and a hot-air balloon.

7. Paint your drawings with acrylic paints and outline them.

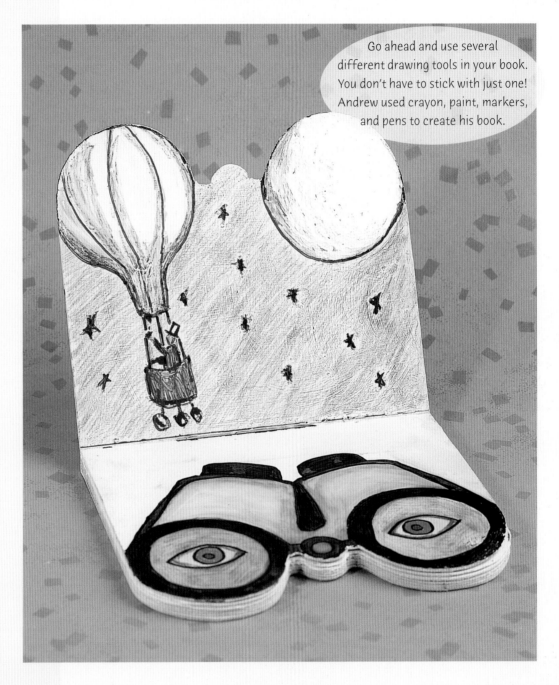

Go ahead and use several different drawing tools in your book. You don't have to stick with just one! Andrew used crayon, paint, markers, and pens to create his book.

Book Drawers

Instead of holding words, this book will hold your stuff. Andrew Bowers had so much fun with this project, he made a whole stack of books for his desk.

Emptying the Book

1. Find several sewn signature hardback books (see page 9).

2. Open the front cover and use a craft knife to slice through the gutter between the endpapers and the text block. Do the same on the back cover.

3. Pull out the text block. Stand it on end on a piece of thin cardboard. Trace around it with a pencil. Add a ½-inch flap to the top and bottom of the outline. Cut it out. Cut another piece of cardboard the same size.

4. Fold in the flaps. Glue the flaps to the front and back cover of the book. This will hold the cover in place.

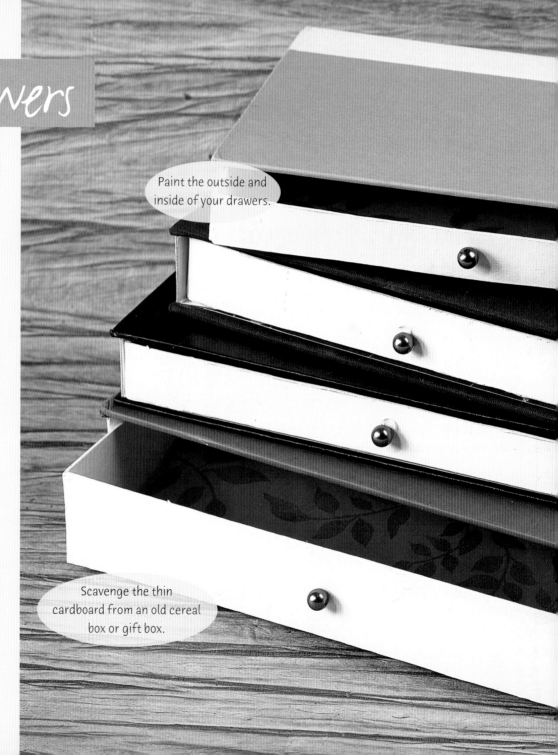

Paint the outside and inside of your drawers.

Scavenge the thin cardboard from an old cereal box or gift box.

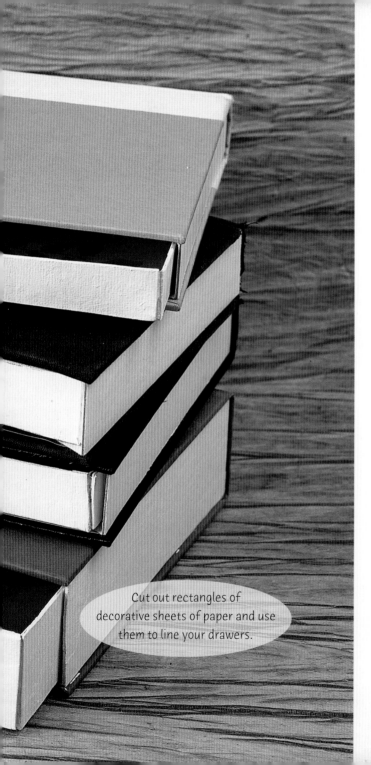

Cut out rectangles of decorative sheets of paper and use them to line your drawers.

Making the Drawers

1. Place the text block flat on a piece of thin cardboard. Trace around it with a pencil. This shape is the bottom of your drawer.
2. Hold the side of the text block next to one side of the outline you traced. Trace around the side of the text block. This will be the side of the drawer.
3. Repeat step 2 to make all four sides of your drawer. Cut out the outlines with a craft knife. Lightly make shallow cuts along the lines where the sides of the drawer meet the bottom. Don't cut all the way through the cardboard, just cut through the top layer.
4. Fold up the sides of the drawer. Use masking tape to stick each side to the one next to it. Put the drawer in the book.
5. Shave off bits of the top with a craft knife if the drawer doesn't fit perfectly.
6. Glue a bead on the front of the drawer.

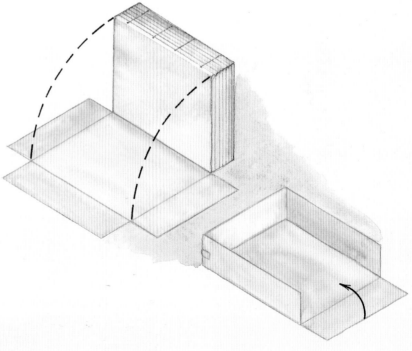

shadow Box

Angela Deane wanted someplace special to display a few of her favorite trinkets, so she turned a book into a shadow box.

Binding the Pages

1. Choose a hardback book that's at least twice as thick as the objects you want to put in it. Cover your work area with waxed paper.

2. Open your book to the center page. (It doesn't have to be the exact center, just close.) Clamp together the pages on either side with binding clips. The clips will hold the book open while you work on it.

3. Spread glue on the edges of the book. Angela spread the glue with her fingers, but you can use an old foam paintbrush if you'd like. Let the glue dry for an hour or so.

4. Remove the binder clips. Spread glue over the places where the binder clips were. Let the glue dry.

5. Spread a thick layer of glue on the inside back cover, and stick the text block to it. Let the glue dry.

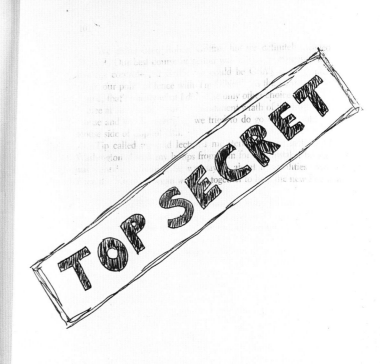

Angela wrote "Top Secret" and signed her name, even though she really wanted people to look at her display. Reverse psychology!

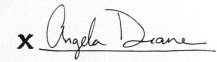

Cutting Niches

1. Lightly gesso both pages of the center spread. Let them dry.

2. Arrange your objects on one page.

3. Trace around the objects with a pencil. Leave a ⅛- or ¼-inch border around each object. Take the objects off the page and set them aside.

4. To make the first niche, use a craft knife to cut around the outline of one of the shapes. Cut through a few pages with each stroke of the craft knife. Don't press too hard on the craft knife. You'll make cleaner (and safer!) cuts if you press lightly.

5. Remove each layer after you cut it. Work slowly and carefully. This may take a few days to do, depending on the depth of your objects. Be sure to take breaks!

6. Once the niches have been cut, paint the insides with gesso. This will bind the pages together.

Book Purse

Create your own purse from a super-thick hardback book. Former fashion designer Nina Surel can turn anything into a fashionable accessory.

Dressing the Cover

1. Find your favorite fabric. Make sure there's enough to cover your entire book. Nina used a fabulous pink- and green-striped print to cover her book.

2. Center the book on the fabric. (The book should be closed.) Using a pencil, trace the perimeter of the book. Add a 1-inch border around the outline you've traced.

3. Cut the fabric along the lines you have drawn. Glue the fabric to the cover of the book. Fold the 1-inch tabs over the covers. Glue them to the inside of the book.

4. Repeat steps 2 and 3 to cover the other side of the book.

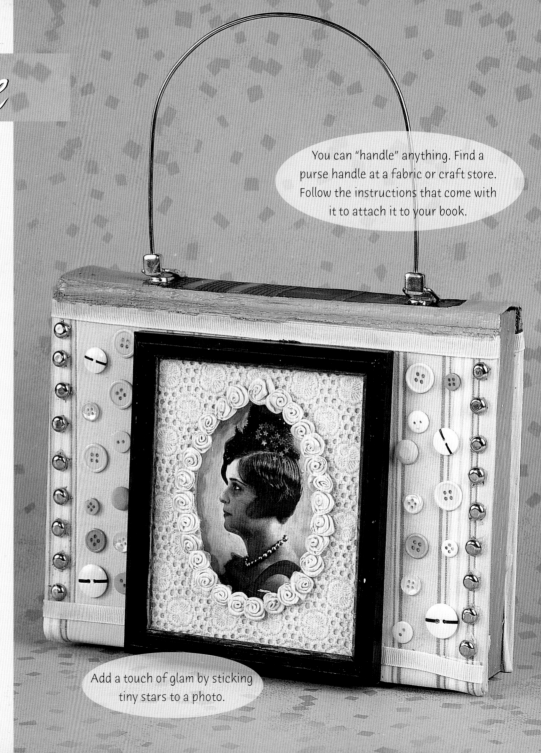

You can "handle" anything. Find a purse handle at a fabric or craft store. Follow the instructions that come with it to attach it to your book.

Add a touch of glam by sticking tiny stars to a photo.

Ribbon Closures

1. Recruit a helper. Four hands are better than two. Open the cover of the book and hold it in place.

2. Have your helper measure the ribbon against the book. The ribbon should be long enough to reach from one corner of the text block to one corner of the cover. Add ½ inch and cut the ribbon. Cut another piece of ribbon the same length.

3. Glue ¼ inch of the ends of the ribbon in place on the top and bottom corners of the book. Hold the ends of the ribbon in place until the glue dries. Glue a button over the ends of the ribbon if you want.

Glue a mirror from the craft store to the inside cover. Go ahead—admire your lovely self.

Hollow out the book by cutting niches (see page 87). Then glue interesting fabrics inside them. Store your beauty secrets inside!

Book Time

It's never been so fashionable to be on time. You can get a clock-making kit at the craft store.

Making a Clock

1. Use a pencil to mark the center of your hardback book on the front cover. Your book should be slightly thicker than the width of the clock mechanism. Ask an adult to drill a hole all the way through the book.

2. Turn your book over. Trace the clock mechanism (the plastic piece that holds the battery) on the back cover.

3. Cut a niche the shape of the clock mechanism into your book (see page 87). Cut through the entire book, except for the front cover.

4. Decorate the cover however you want. I painted my cover green.

5. Following the instructions that came with it, insert the clock mechanism.

6. Add numbers in the appropriate places on the front cover.

Cut out words or numbers from magazines or old books and glue them on. The scrapbooking aisle at the craft store has tons of numbers in all different fonts, sizes, and colors.

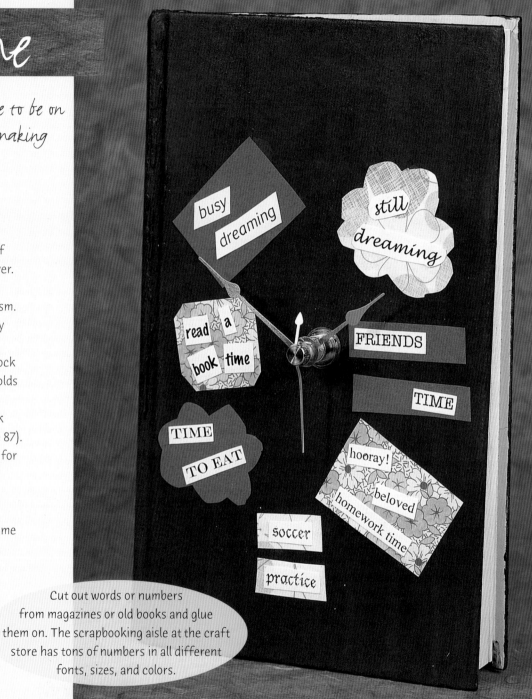

Cover Relief

Put an alien in the window on the ship. If your UFO photos didn't turn out, draw an alien.

Instead of drilling stars, you could paint them directly on the cover.

Blast off with this cover project! Andrew Bowers got out his toolbox to make this rocket ship.

Sanding Off the Cover

1. Choose a hardback book for this cover. Draw the outline of a simple shape on the cover with a pencil. Andrew chose to make a rocket ship. Carefully cut around the outline with a craft knife.

2. Put on a dust mask. Sand the space around your outline with rough sand paper (like 80-grit). This will make the background actually drop off.

3. If you'd like to put some holes in your cover, get an adult to help you drill through it. Make sure you do this on a hard work surface (one that nobody's going to be upset about having a few accidental holes in). Andrew used the drill to make stars.

4. Andrew wanted to make it look like someone was riding inside the cockpit in his rocket, so he cut a hole in the cover and placed a picture behind it. Use a box cutter to make the hole. Work slowly and be careful with the cutter.

5. Paint your cover. Don't use more than three or four colors.

Hollow Down

Don't just change a page or two in your book.
Change the entire thing, like fashion designer
R. Brooke Priddy did.

Cutting the Holes

1. Divide the pages of a thick hardcover book into three sections. Put a piece of wax paper between each section.

2. Glue the edges of the pages in each section together (see page 86). Let the glue dry.

3. Put a stiff piece of cardboard behind the first section. Draw the outline of the shape you want to make. Using a craft knife, cut out the outline, making a hole in the section (see page 87).

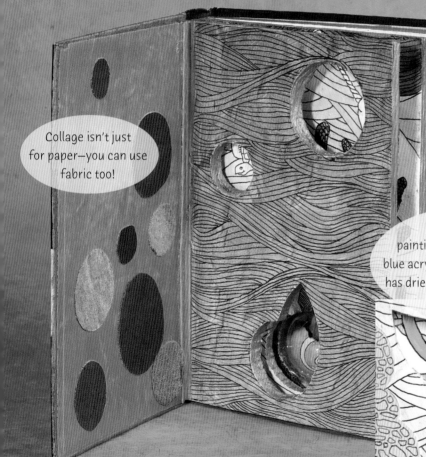

Collage isn't just for paper—you can use fabric too!

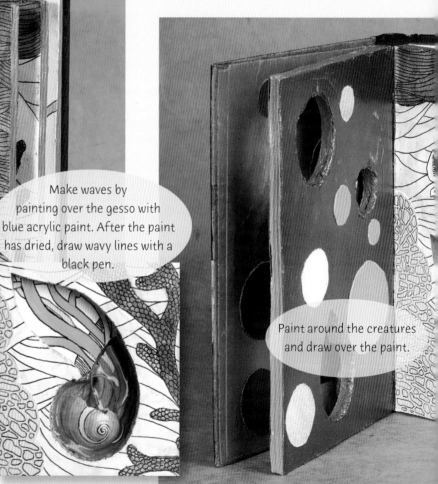

Make waves by painting over the gesso with blue acrylic paint. After the paint has dried, draw wavy lines with a black pen.

Paint around the creatures and draw over the paint.

4. Brush glue around the inside of the hole. Let the glue dry.

5. For the other two sections of the book, repeat steps 3 and 4. Change the shape and placement of some of the holes. Let the holes overlap in some places.

6. Paint the inside of the holes, and then gesso over the pages. Let the paint dry.

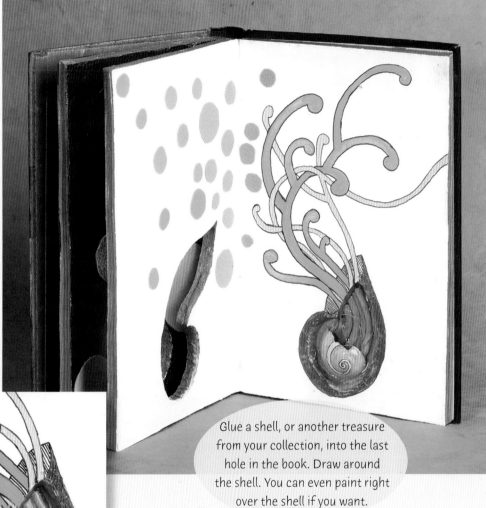

Glue a shell, or another treasure from your collection, into the last hole in the book. Draw around the shell. You can even paint right over the shell if you want.

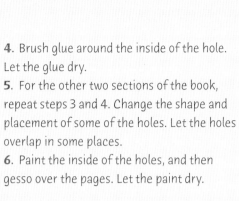

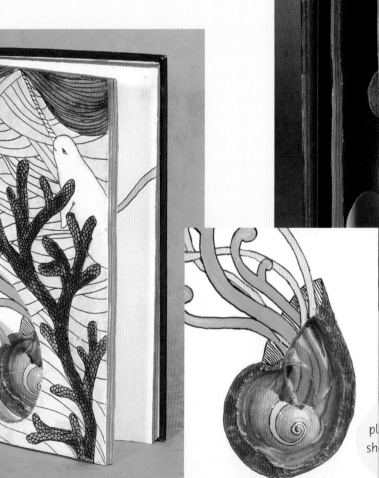

Draw sea creatures and plants. Position them so they show through the holes in the first chunk of the book.

Glossary

Analogous color scheme. A color scheme consisting of three or more colors found next to each other on the color wheel.

Asymmetrically balanced. A picture that can't be divided into two halves that mirror each other but is still balanced.

Background. The decoration behind the main part of your picture or the part of a landscape farthest from you.

Binding. How the pages of a book are held together.

Complementary color scheme. A color scheme consisting of colors that are across from each other on the color wheel.

Cover. The front and back of a book.

Emphasis. The place in a picture that catches your eye.

End Papers. Thick papers glued to the inside of the covers and the outside of the text block.

Foreground. The part of a landscape closest to the viewer.

Gutter. Where two pages meet inside a book.

Horizon. The line where land or water meets the sky.

Middle ground. The part of a landscape that lies between the background and the foreground.

Monochromatic color scheme. A color scheme consisting of different shades of the same color.

Pattern. A repeating shape, color, or line.

Perfect bound. The type of binding in a book in which the pages are glued together.

Proportion. The relationship between the size of two or more things.

Repetition. Using the same shape, color, or line over and over to make a pattern.

Sewn signature. The type of binding in a book in which the pages are sewn together.

Spine. The back edge of the book, where the title and author's name are printed.

Spread. Two pages that face each other in a book.

Symmetrically balanced. Dividing a picture into two halves that mirror each other.

Text block. All the pages inside of a book.

Translucent. See-through.

About the Artists

Ashley Alexander Baxter lives in Chicago, Illinois, with her husband, her dog and their two cats. She wants to make art available to everybody, every day, not just something that hangs in galleries. She loves drawing, taking walks, dancing, singing, and eating cupcakes. (But not all at the same time!) Her projects are on pages 58 and 78. You can see more of her work at www.imsmitten.com.

Andrew Bowers is a maker of all things. His favorite things to make are popcorn, bad jokes, and furniture. He finds inspiration in the ocean, his lovely wife (who wrote this book!), and watching his dog swim in the nearby river. He lives in Asheville, North Carolina. His projects are on pages 72, 80, 82, 84, and 91.

Angela Deane is a Florida girl who packed her bags for New York City. Trading year-round sun for a half-a-year of snow has given her more time to work in her studio, where she creates fashion and art. She has her own line of clothing and is part of the Hayvend art troupe. Angela is obsessed with all things miniature. Her projects are on pages 34, 68, and 86. You can see more of her work at www.christopherdeane.com and www.theresmagicafoot.com.

Robin Gregory is an art director at Lark Books. She lives in Asheville, North Carolina and loves vacationing at the beach. Her sons helped her design the project on page 48.

Ted Harper spends most of his free time making sculptures, drawing, skateboarding, and enjoying the company of friends. Right now, Ted makes art because he has to. He hopes to someday make art for a living. He exhibits his work in Asheville, North Carolina, where he lives in a studio in the arts district. His projects are on pages 32 and 56.

Amethyst Hawkins moved from Santa Fe, New Mexico, to Portland, Oregon, to pursue a BA in Applied Linguistics. In her spare time, she creates all manner of things and is constantly engaged in the exploration of self. She has been binding books professionally since 2000. Her projects are on pages 49 and 50.

Jane Hennessy is a longtime artist, designer, and muralist. Besides being a proud mama of three (including one who wrote this book!), she enjoys cooking, travel, poetry, and constantly rearranging her furniture. Her project is on page 66.

R. Brooke Priddy, designer and dressmaker, studied in San Francisco and developed a clothing line in New York City before moving south to set up her dressmaker's studio, Ship to Shore. She's inspired by the sea, and many people think her dresses are designed with the weightless world of the deep ocean in mind. She can often be found stitching spandex and drawing pictures in Asheville, North Carolina. Her project is on page 92. Visit the Ship to Shore Shop online at www.shiptoshoreshop.com.

Kelly Rae Roberts didn't start making art until the year she turned 30. Now, she's a mixed media artist in Portland, Oregon, where she lives with her husband, John, and their very sweet dog, Bella. When not creating, she's exploring the outdoors with John, having hot tea with a friend, rearranging her furniture, driving and singing with the windows down, or talking on the phone with her beloved mom who lives 3,000 miles away. Her projects are on pages 40, 60, and 74. To see more of her work, visit www.kellyraeroberts.com.

Nina Surel is a mixed-media artist, and has worked as a fashion, textiles, and costume designer. She was born in Buenos Aires, Argentina, and has received awards for her artwork in many places, including Miami, Atlanta, and Buenos Aires. Currently, Nina is using her art to comment on the stereotypes Western women face every day. Her project is on page 88. See more of her work online at www.ninasurel.com.

Acknowledgments

Thank you to all the people who made this book possible, especially: my artist friends who contributed their lovely and diverse talents to this book. I appreciate your time and creative generosity immensely. Rain Newcomb, my brilliant editor, whose tireless dedication to this book was inspiring to witness. Skip Wade, Steve Mann, Robin Gregory, and Celia Naranjo, who made these wonderful projects look amazing. And finally, to my beautiful mother, Jane Hennessy, who has always been my number one supporter and closest friend.

Index

Metric Conversion Chart

Inches	Centimeters
⅛	.3
¼	.6
½	1.3
¾	1.9
1	2.5
1½	3.8
2	5
2½	6.4
3	7.6
3½	8.9
4	10.2
4½	11.4
5	12.7
5½	14
6	15.2

To convert inches to centimeters, multiply by 2.5.